the CARTOONIST'S WORKSHOP

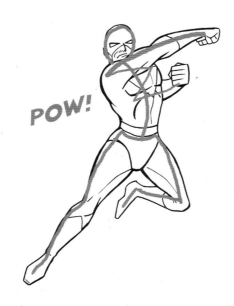

POW!

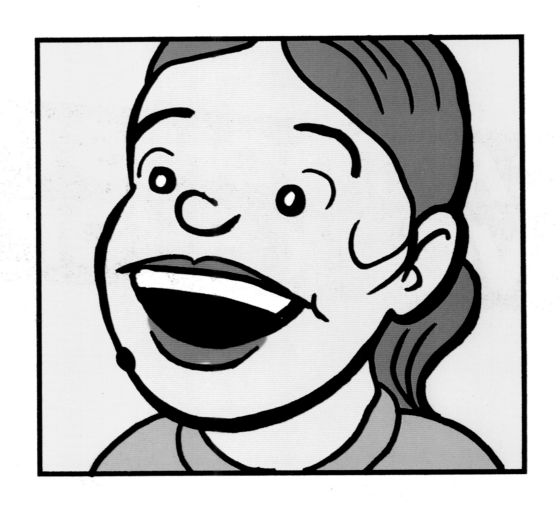

the CARTOONIST'S WORKSHOP

STEVE MARCHANT

COLLINS & BROWN

First published in Great Britain in 2004 by
Collins & Brown Limited
The Chrysalis Building
Bramley Road
London W10 6SP

An imprint of **Chrysalis** Books Group

British Library Cataloguing-in-Publication Data:
A catalogue record for this book is available from the
British Library.

ISBN: 1-84340-146-0

Artwork by Steve Marchant
Designed by Jon Morgan
Edited by Julie Jones
Indexed by Sue Bosanko
Proofread by Tamsin Shelton

Reproduction by Anorax Imaging
Printed and bound by Times Printing, Malaysia

CONTENTS

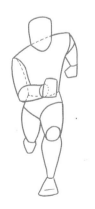

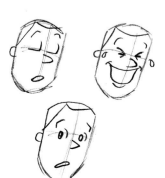

INTRODUCTION 6

CHAPTER 1:
BEGINNERS START HERE

TOOLS AND EQUIPMENT 10
BASIC TECHNIQUES 14
COMPUTERS 22

CHAPTER 2:
THE FACE AND FIGURE

FACIAL PROPORTIONS 26
FEATURES OF THE FACE 28
DRAWING THE FACE FROM
 DIFFERENT VIEWPOINTS 30
FACIAL EXPRESSIONS 32
FACE PROJECT 34
FACE PROJECT
 ASSESSMENT 36
FIGURE PROPORTIONS 38
ANTHROPOMORPHOUS
 ANIMALS 40
MUSCLES MADE SIMPLE 42
CLOTHES AND COSTUMES 44
HANDS AND FEET 45
THE MOVING FIGURE 46
FORESHORTENING 48
FIGURES PROJECT 50
FIGURES PROJECT
 ASSESSMENT 52

CHAPTER 3:
PLACES AND OBJECTS

BASIC RULES OF
 PERSPECTIVE 56
INDOOR SCENE 60
OUTDOOR SCENE 62
PERSPECTIVE PROJECT 64
PERSPECTIVE PROJECT
 ASSESSMENT 66
ESTABLISHING AN
 ENVIRONMENT 68

POINTS OF VIEW 70
SINGLE PANEL PROJECT 72
SINGLE PANEL PROJECT
 ASSESSMENT 74

CHAPTER 4:
COMPOSITION AND
STORYTELLING

PICTURE COMPOSITION FOR
 CARTOONS AND COMIC
 STRIPS 78
PAGE LAYOUTS 82
REFINING YOUR STYLE 84
WORKING FROM A SCRIPT 88
FULL-PAGE PROJECT 90
FULL-PAGE PROJECT
 ASSESSMENT 92

CHAPTER 5:
PRESENTATION AND
PUBLICATION

ASSEMBLING A PORTFOLIO 96
SELLING WORK LOCALLY 97
PUBLICITY AND PROMOTION 98
COPYRIGHT, CONTRACTS,
 MONEY AND TAX 100
PREPARING WORK FOR
 PUBLICATION 101
WHERE DO YOU GET
 YOUR IDEAS FROM? 104
FINAL PROJECT – PRODUCING
 YOUR OWN COMIC BOOK 106

GALLERY 111

INDEX 124

ACKNOWLEDGEMENTS 128

INTRODUCTION

Today, cartoons surround us in:

- newspapers
- magazines
- comic books
- advertising
- information leaflets
- posters
- greetings cards
- cereal boxes
- children's books
- graphic novels
- the Internet ...

... in Japan they are even printed directly onto slabs of bubblegum. And, of course, we've all grown up watching animated cartoons on television, the cinema and on the worldwide web. Since the dawn of mankind, people have striven to communicate using a few simple lines to represent the world around them. Arguably, the first cartoons can be seen on the walls of caves depicting the great hunt, a fierce battle or the king slipping on a banana skin. The tombs of ancient Egypt are lined with hieroglyphs and pictures that show us how those people lived. The written languages of China and Japan are based on pictograms – simple outlines that communicate an idea.

Thousands of years later we're laughing along with *The Simpsons*, gasping at the uncanny exploits of *The X-Men*, or shedding a secret tear as we read moving tales by Chris Ware and Raymond Briggs. Every day we can pick up our newspaper and enjoy cartoonists lampooning our leaders and commenting on world events. Using the Internet, we can see cartoons drawn by people all around the world. Things have moved on since Ug the Caveman dipped a stick into some goat's blood and drew his donkey on the wall!

There are already large numbers of books on cartooning, but many of them focus exclusively on one particular style or even on one set of established characters. There are some that I'd recommend to their intended audience, but few offer a

broad overview of the field, combined with the underlying techniques used by professional cartoonists all around the world. Fewer still are written by professional tutors who understand the process of learning. Too often you'll open a "How to Draw Cartoons" book that will show you a simple stick-figure next to a page fully finished drawings, with little or no indication of the steps in between.

This is where *Cartoonist's Workshop* is different. As you read, you'll be taken from the bare basics, step by step, through to a reasonable standard of drawing cartoons and comic strips, touching on a variety of styles. There are projects to attempt, consolidating what has been learned at each stage, with feedback based on typical difficult issues that arise. At the end, you'll

be led through the process of creating and publishing your own comic book. And finally, there's a Gallery section that allows you to learn from some of the world's greatest cartoonists.

Whether you intend to draw cartoons as a hobby, use them in your workplace or illustrate a major comic book some day, this book should get you off to a flying start.

8

Chapter 1:

BEGINNERS START HERE

TOOLS AND EQUIPMENT

In this section we take a look at some of the typical tools of the cartoonist. Most of these items are readily available at your nearest shopping centre, but a few can only be found at a specialist art/graphics supplies store. However, none of them should be terribly expensive.

Your drawing space

You're going to need somewhere comfortable to sit and a surface to work on, typically a chair and table. It's a good idea to get yourself a drawing board to rest on, something flat and smooth, such as a sheet of hardboard from your local DIY store.

Alternatively, you could buy a draughtsman's drawing table, but these are expensive, take up a lot of space and are not strictly necessary for the beginner.

Personally, I like to draw while lying on the floor in the lounge.

Paper

The thickness and texture of paper can affect the way your work appears. Ordinary photocopying paper will suffice for many purposes, but it isn't very robust and is prone to wrinkle and crease.

Cartridge paper is more hard-wearing and cheaply available in sketch pads. It has a slightly grainy surface that some artists prefer to work on, but many choose Bristol Board, which is a smooth card available in graphics supplies shops as pads or single sheets.

The best thing to do is to experiment with different kinds of paper until you find one that suits your drawing materials best. In the end, you may decide to have some cheap paper for rough sketches and a separate pad of better paper for your finished work.

Pencils

Pencils come in varying degrees of hardness. A very hard pencil will give you a sharp, clear line, but can be difficult to erase. Using a very soft pencil can make drawing details a tricky endeavour and it will smudge easily. Logic dictates that you might prefer a pencil that is somewhere between the two extremes, so, again, experiment until you find the kind of pencil that's right for you.

Mechanical "propelling" pencils have the advantage of always staying sharp, which can be useful. Otherwise, you'll obviously need a pencil sharpener. It's good to buy a few of these at a time, as their blades can become less sharp with use and tend to splinter the wood of your pencil.

And, of course, you'll need erasers. Plastic erasers are available, but these can sometimes smudge your pencil marks indelibly into the surface of the paper. Old-fashioned rubber erasers are the best. Avoid coarse "ink erasers", as they will scratch your paper, spoiling things at the inking stage.

Pens

There is no "magic pen" used by cartoonists. Until the 1990s, old-fashioned dip-pens were commonly used with a bottle of black India ink. Line-work needed to be presented as black as possible for the reproduction processes of the time and, as India ink is waterproof when dry, it was suitable for painted colour. Computer technology has rendered most of these issues obsolete, but many cartoonists still prefer the dip-pen because its choice of flexible nibs gives a lively quality to their line-work. However, dip-pens do need to be repeatedly dipped into ink and each line can take minutes to dry, which makes it easy to accidentally smudge your work. With practice, though, they can be an invaluable drawing tool.

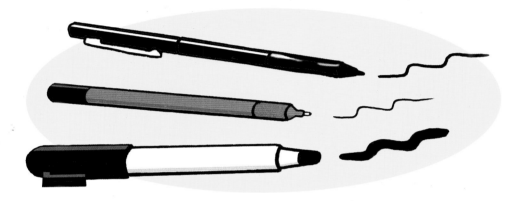

Nylon-tipped markers come in a range of thicknesses and are relatively inexpensive. A few are available with a flexible tip that allows you to mimic the effect of drawing with a dip-pen. Fountain pens are used by some artists.

Technical drawing pens will give you a line of consistent thickness and are useful for drawing mechanical objects and architecture. Bear in mind that a line any thinner than 0.5 millimetres will not reproduce well and can even disappear on the printed page, especially if your artwork is reduced for publication.

Ballpoint pens are not recommended for inking your work. Their lines suddenly fade to grey for no apparent reason; small blobs of ink will appear and mess up your work. They're useful for rough sketching and writing shopping lists, but little else.

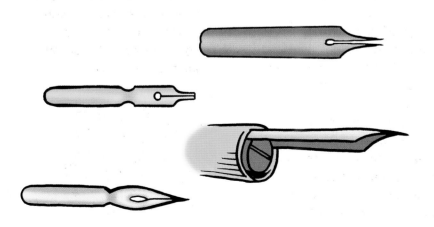

Brushes

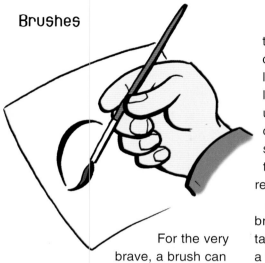

For the very brave, a brush can be used to ink your work instead of, or along with, a pen. A small, sable-hair brush is recommended because the cheaper nylon brushes will never come to a nice point at the end. A larger brush can be used to fill in large black areas. As with a dip-pen, using black India ink is best. Always clean your brush thoroughly with soap and water after use; otherwise the ink will dry in the bristles and render the brush unusable.

A nice combination of pen and brush is the brush-pen – this takes small cartridges of ink, like a fountain pen, but it has a finely tipped brush at the end instead of a nib. Cheaper, disposable versions are also available.

If you do attempt to ink your work with a brush, I'd recommend drawing lines away from your body (as opposed to toward yourself, as we tend to draw with a pen). This will help keep your line-work steady. Practice, as ever, makes perfect!

Correction fluid

Originally invented for typewriters (in fact, by the mother of Michael Nesmith, of the 60s pop stars The Monkees …), correction fluid is incredibly useful for rectifying small mistakes at the inking stage. Be careful, though, as you'll find that some pens will draw over the corrected area easily, but others won't. Ironically, perhaps, ballpoint pens tend to work reasonably well over correction fluid.

Correction fluid pens are also available, and are equally useful.

Rulers and drawing guides

When choosing a ruler, bear in mind that the wooden ones dent easily and lose their perfectly straight edge, so a plastic or steel ruler is better. Also, make sure your ruler has a bevelled surface – by turning your ruler over onto its bevelled side when using a pen, its edge does not touch the paper, reducing the risk of smudging your lines.

Set-squares are particularly useful for drawing 90-degree angles (such as panel borders). Most department stores sell inexpensive packs of rulers and set-squares in their stationery sections, and these are perfectly adequate for the beginner.

Ellipse templates are great for drawing word balloons, and circle templates are much easier to use with a pen than a drawing compass. Like rulers, these often come with a bevelled side for inking.

French curves are pretzel-shaped slabs of plastic that can help you draw smooth, curved lines by choosing the appropriate section and using them as a ruler.

Hands and eyes
Look after them – you'll need them!

BASIC TECHNIQUES

The art chores of many cartoons and comic strips are often split between several people: penciller, inker, colourist ... even letterer. However, aside from mass-produced, weekly/monthly comic books, all of these jobs are usually handled by the same person, who might even have written the material. With that in mind, let's examine the basic techniques of these areas.

Pencilling

Virtually every cartoon begins as a pencilled sketch, using simple shapes to build the elements of the picture before adding the details.

You might have seen cartoonists on television or at comics conventions who draw straight-off with a pen, producing a decent, finished drawing in a few minutes.

Every seasoned professional has a few "party pieces" they can produce without any pencilled preparatory drawing. For the beginner, that path leads to maddening frustration, but remember that even the professionals will be reaching for their pencils once they're back at the drawing board.

All your pencilled drawings will be either covered with ink later, or erased, so it's important to use your pencil lightly. Pressing too hard into the paper makes erasing difficult. If you can see your pencilled drawing as you work on it, great – if someone 5 metres away can see it at the same time, you're pressing too hard with your pencil.

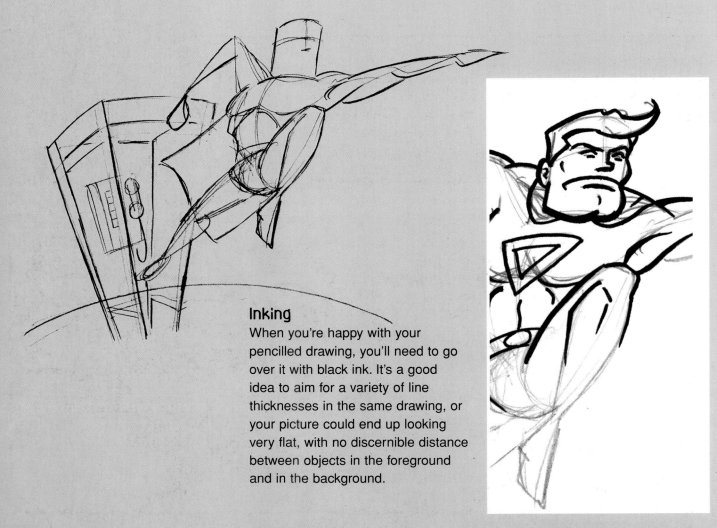

Inking

When you're happy with your pencilled drawing, you'll need to go over it with black ink. It's a good idea to aim for a variety of line thicknesses in the same drawing, or your picture could end up looking very flat, with no discernible distance between objects in the foreground and in the background.

Here we see the same two cartoons inked using different methods.

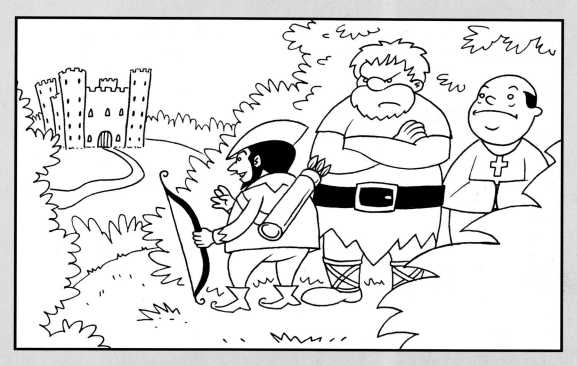

The first has been inked using the same fine-line pen throughout, and the background seems to be as close to us as the foreground.

The second picture has been inked with lines of differing thickness, adding bolder outlines to the foreground elements, and thicker lines to the underneath of objects, suggesting form and shadow.

Hatching

Many cartoonists use line-shading, or "hatching", to add an illusion of depth and/or texture to their work. It can also be used to create a middle tone between black and white, as the eye will perceive closely printed lines or dots as a kind of "grey".

Here are the most commonly used methods:

Hatching: simple, thin, parallel lines used around the edge of a drawn object, or to fill a section of an object.

Flicking: best achieved with a dip-pen, or other very flexible nib. The tip of the pen is pressed onto the paper and then flicked to the side.

Stippling: tiny dots that might be grouped closely together and gradually spaced further apart, or randomly spread to indicate a rough texture to surfaces.

Cross-hatching: as above, but with lines crossing at a different angle, filling space more completely but still allowing the white of the paper to show through.

Feathering: a brush is best for this technique. It's almost the opposite of flicking, as the tip of the brush is placed at the edge of a black area and then drawn back into it, pressing harder as you go. This has the effect of softening the transition from white to black in areas of your picture, and is often used when drawing hair or the folds in fabric.

Mechanical tones: dots or lines printed onto a clear adhesive sheet that can be cut into sections and stuck onto your work. Widely used in Manga (Japanese comics), but elsewhere superseded by similar effects available in computer graphics programs.

Lines used for all of these effects should be finer than the main outline so as not to overwhelm the image, but no finer than 0.5 millimetres or they may disappear if your work is reduced in size for printing. A grey watercolour wash or pencil shading might look great on your actual artwork, but unless it's to be printed at a very high photographic resolution, you will be disappointed when it reproduces as a patchy, uneven mess.

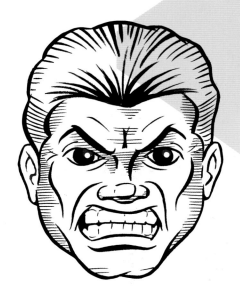

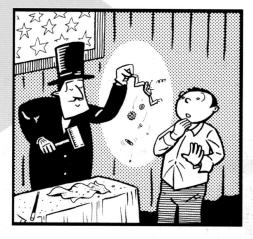

Here are two examples of how areas of solid black, solid white and hatching can be used harmoniously in the same picture:

Feathering on the hair and light hatching around the edges and recesses of the face give it a rounded appearance.

Solid black on the magician and a white spotlight on the broken wristwatch stand out against the mechanical tone on the background.

White flicking on the magician's top hat gives it a rounded appearance. The white tablecloth, black floor and hatching on the punter's trousers all contrast nicely across the bottom of the panel.

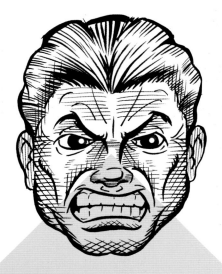

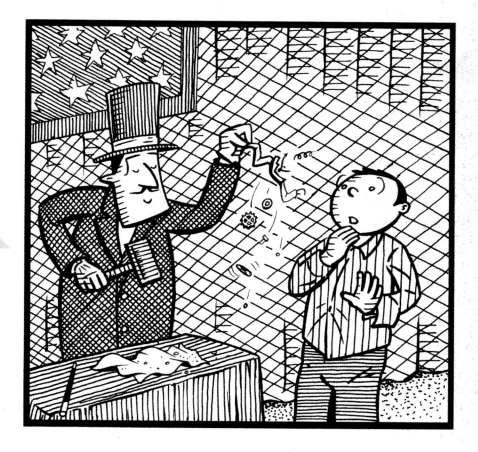

Here's how too much hatching can make the elements of those same pictures hard to distinguish:

The face has been over-worked with feathering and cross-hatching, to the extent that it obscures the main details of the picture.

While the close cross-hatching on the magician's body is okay, and the hatching on his hat and the punter's trousers work quite nicely, there is too much hatching on every surface, making the separate elements of the picture less distinct.

Colouring

Until the advent of computer colouring programs (and we'll get to computers in a moment), cartoon illustrations were usually coloured by hand, using watercolour paint, gouache, coloured marker pens, or sometimes even coloured pencils. These techniques are still used, but mostly in the traditional editorial cartoons of newspapers, or illustrations for children's books. This is not to say that these methods should no longer be used, merely that computers offer a faster and more versatile option.

No matter how you might apply colour to your work, there are a few important points you should consider.

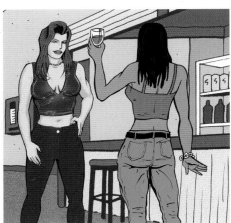

Recurring characters in cartoons tend to wear the same colour clothing to be easily identified in any situation.

Background colours should not be the same as the foreground.

Backgrounds tend to be rendered in paler colours so that characters can be more easily seen.

"Hot" and "cold" colours can be used to add mood to a picture, or sequence of pictures.

Hot colours:
red, orange, yellow

Brown, as a mixture of red, yellow, and blue, can be either

Cold colours:
green, blue, violet

Obviously, hot colours could be used to depict a sunny day and cold colours for a winter scene; but these colour schemes can also be used to emphasize the emotional quality of a picture: hot colours are vibrant, lively and exciting; cold colours can seem drab and gloomy, or peaceful and calm in lighter shades.

Complementary colours are those shades that lie at opposite sides of the spectrum – red and green, blue and orange, yellow and violet; they stand out against each other in the same manner that black stands out from white, and vice-versa. This can be quite jarring for the eye: it can make a main character more noticeable, but it's a disaster for interior decorating!

If you're using paint or markers to colour your work, you must ensure that it's been drawn with waterproof ink; otherwise it can literally dissolve and be ruined. It's worth remembering that the ink used in photocopying is waterproof, so you can colour a photcopy of your work if it's been drawn with non-waterproof materials.

For computer colouring, your choice of materials is not a problem, as we will see later.

Lettering

Although computers are often used to add captions, dialogue and sound effects to cartoons, legible hand-lettering remains a vital skill.

Hand-lettering is not the same as handwriting. Your own handwriting might be perfectly readable to you, but not to many others. The lettering in your cartoons must be clear enough for anyone to understand. To that end, it's advisable to use CAPITAL LETTERS, which are more defined than lower-case letters.

In order to keep our lines of text straight and consistently formed we can rule guidelines in pencil. You might try ruling them about 5 millimetres apart, with a gap of 2–3 millimetres between each line of text.

Here's an extra tip: for some magical reason, if you angle the horizontal parts of letters just slightly upward, they will tend to look the same each time you write them!

Caption boxes at the top of panels are usually used for exposition, for example:

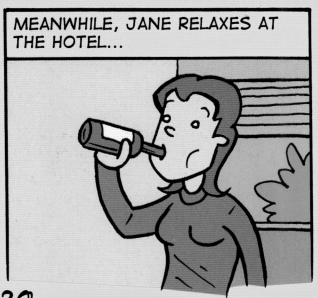

MEANWHILE, JANE RELAXES AT THE HOTEL...

Dialogue is normally enclosed in a word balloon, with a "tail" pointing toward the speaker.

If the word balloon is drawn with a broken line, it means the character is whispering.

A jagged outline shows that a character is shouting loudly.

Thoughts are indicated by words in a cloud-like shape, trailing small "bubbles".

Spacing your words to mimic the shape of an oval ensures you'll have nice, regularly shaped balloons.

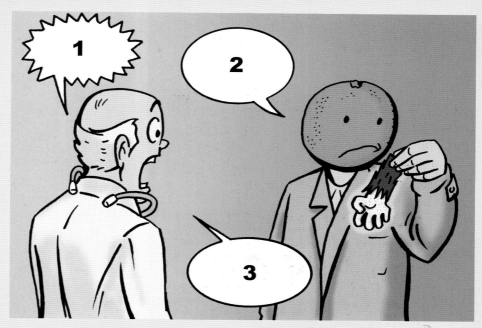

When arranging the word balloons in your picture, remember that we read from left to right (except for people in the Middle East and Far East) and down the page.

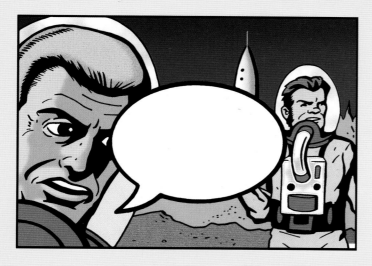

It's also useful to try and place your word balloons where they will not obscure any important part of the picture.

Sound effects should be drawn as neatly and carefully as any other element of your picture; you can have fun with trying to let their outlines describe the quality of the sound.

COMPUTERS

The computer has become an incredibly useful tool to aid and enhance many aspects of cartoon illustration. However, it cannot (as yet!) do the drawing for you. So, you will not need a computer to complete any of the exercises in this book. Most cartoons and comic strips intended for the printed page are still hand drawn on paper and many are still lettered and coloured by hand. In its present form, as far as cartoon work is concerned, the computer is really a glorified paintbox and typesetting machine, and a handy resource for sending, receiving and archiving material.

If you're fortunate enough to have access to a computer, however, the following pages should give you enough basic information to experiment with your own work. Apologies if you're reading this in the year 2025 as it will all seem laughably out of date.

Whichever graphics program you choose to work with, I strongly suggest you read one of the many support manuals available, in order to familiarize yourself with its capabilities and peculiarities.

As well as the standard computer set-up, a number of peripherals are essential for the high-tech cartoonist. Fortunately, these days they can be bought relatively inexpensively.

Scanner

You'll need one of these to copy your drawings into the computer. Most scanners are letter-document sized, so if your original artwork is larger, you'll need to get it reduced at a photocopy shop and then scan the copy.

To preserve the details of your work, always scan at a resolution not less than 300 dpi (dots per inch). Your scanner's software should allow you to alter its default settings either before or during the scanning process.

Graphics tablet

If you've ever tried to draw pictures on your computer screen with a mouse, you'll have discovered that it's like trying to draw with a bar of soap! A graphics tablet gives you complete fingertip control as you trace along its surface with a special "pen" and the movements are instantly converted into lines or marks on-screen. Most cartoonists, however, still draw onto paper, scan the drawing into the computer and use a tablet for corrections and colouring. Drawing directly onto the computer screen can be a maddeningly difficult process, but if you're feeling brave …

Printers and paper

An ordinary inkjet printer will produce results much closer to the quality of your on-screen image if you use photo-quality paper and use your printer's best settings. Photo-quality paper is now affordably available at many high street stationers and comes in both matt and gloss finish.

Storage devices and file formats

At some point you'll need to copy work from your computer's hard drive onto something more portable, especially if you're sending work to a client. Storage devices are changing and improving almost yearly – current devices are floppy disks, zip disks, CDs and DVDs.

Whichever you choose, ask your client which file format they prefer to use. When you save your work on the computer, you'll be offered a choice of formats. TIFF is widely used and can be opened by any other program, as can files in JPEG and Bitmap format, although they will be of slightly inferior quality. Avoid saving graphics in Word format as these can only be opened in the Word program.

Many cartoonists, illustrators and designers use an Apple Mac rather than a standard PC for producing art and graphics, although both are equally efficient these days. Learning the basic skills to become a cartoonist, however, does not require a computer at all, so please don't feel the need to get a new computer just yet!

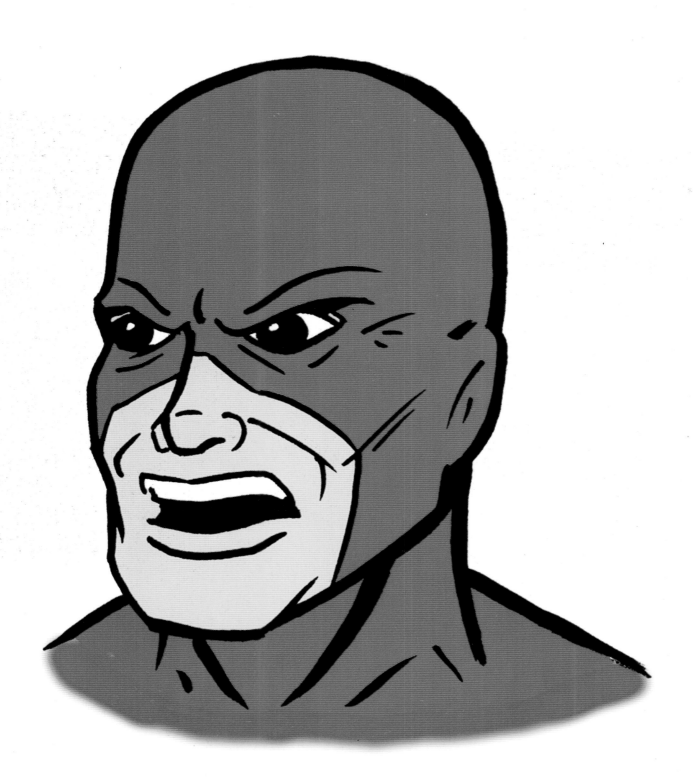

Chapter 2:

THE FACE AND FIGURE

FACIAL PROPORTIONS

As we've already seen, there are many different ways of drawing facial features; but where do we put them in relation to each other?

How can we keep our characters looking consistent, so they'll appear the same each time we draw them?

The answer is guidelines! Each face, whether realistically rendered or exaggerated for comic effect, uses the same basic guidelines to anchor the features.

Guidelines: the essential element

Here are the guidelines for a realistically proportioned human face, such as you might see in any cartoon where the characters are meant to look like you or me.

Lightly sketch an oval for a "starting shape" and draw a central guideline straight down the middle – this will help us to keep the facial features the right length and the correct distance apart.

Draw an "eye line" across the middle, and halfway between this and the chin, draw a "nose line".

Draw a guideline for the mouth at approximately one-third of the way down the remaining distance.

The eyes sit on the eye line, at an equal distance from the vertical central line – on a realistic face this space should be the same as the width of one eye.

Beneath the eyes, draw a line parallel to one side of the central line to show one side of the nose – we don't usually draw lines for both sides of the nose as this can give it a "trunk-like" appearance. Where the central line crosses the nose line we draw the tip of the nose, taking care to draw it equally spaced from either side of the central line.

The ears are drawn between the eye line and the nose line.

The mouth should be drawn along its guideline, once again taking care to keep each side an equal length from the central line.

Add hair, and modify the shape of the jaw to suit your character.

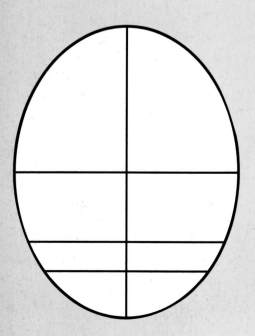

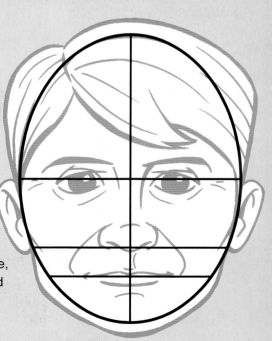

Cartoon faces use the same guidelines. In humorous cartoons the shape of the head and the proportions of the face can be stretched and exaggerated, but the accurate use of guidelines ensures that even a head of outlandish proportions will look the same every time that character appears. Here we have a selection of heads drawn using a variety of non-realistic shapes and proportions – the guidelines have been moved around to allow for exaggeration.

The eye line has been raised from the centre of the head, and the nose and mouth lines have been combined to accentuate the chin.

Here the guidelines have all been lowered to give this character a huge forehead.

When we exaggerate the space for the nose, we have to decide whether to align the ears with the guidelines of the eyes or the nose, or draw them halfway between. There's no right or wrong with this, simply whatever you decide looks best for your character.

It's good to take simple measurements of where you've placed your modified guidelines, as you can see alongside these illustrations. By using the same proportions each time you begin drawing your characters, they'll look the same every time.

FEATURES OF THE FACE

Cartoonists around the world use a variety of lines and shapes to draw the eyes, nose, mouth and other features of the human face. Some aim for a realistic result, while others prefer a more simplified or exaggerated style. Many more fall somewhere between the two extremes or adopt different styles to suit their purpose.

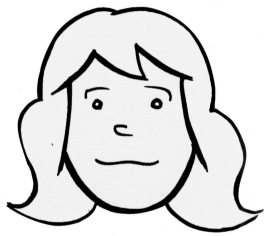

Here's a face drawn in a realistic style, with all the lines drawn to mimic the natural ridges, folds and furrows of a typical human face. You might typically find this kind of cartooning in romance, war or super-hero comics, where the aim is to show things – even extraordinary things – in a convincing, believable way.

Here's the same character drawn in a much simpler style, typically used in humorous strips and illustrations. However, this style can also be effectively used for any purpose, including those genres mentioned above.

Many cartoonists feel that a more simply drawn character allows for greater reader identification. But one style is not "better" than the other!

Before moving on to look more deeply at facial proportions, and drawing the head from different angles, let's get warmed up with a fun exercise.

PROJECT

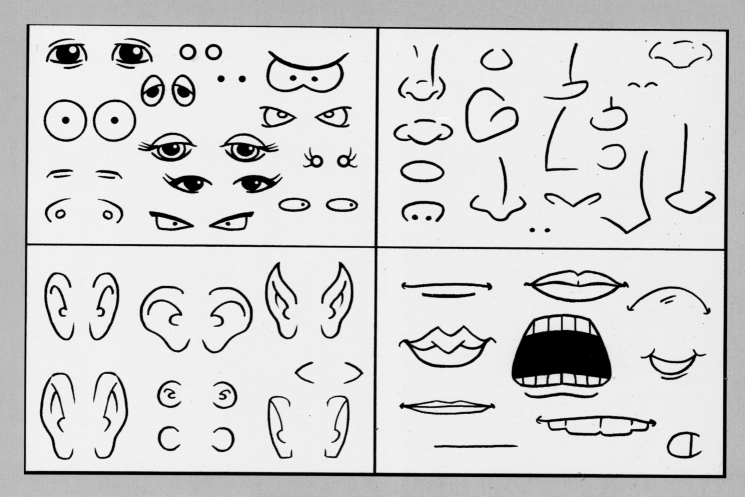

Here is a selection of differently styled ways of drawing the features of the face. All you need to do is lightly sketch a "starting shape" for the head – an oval, a rectangle, a triangle, whatever you like – then choose a set of features from each section. Carefully copy them onto your drawing.

Hair

Take a look at the faces on the previous page for tips on drawing hairstyles. The hair for a realistic face is drawn as an assemblage of flowing shapes, with lines indicating the direction of the hair's growth.

Don't try to draw every single strand of hair. A more cartoony face is topped with hair drawn as a simple outline, with perhaps a few lines within.

You should by now have created your own cartoon character!

DRAWING THE FACE FROM DIFFERENT VIEWPOINTS

The guidelines we've been using to define our characters' facial features are also useful when we need to examine how to draw the head from different angles.

Perhaps the most obvious thing to remember is that the outline of the head changes shape as it turns. How much that shape alters depends on the kind of character you are developing, as we can see below.

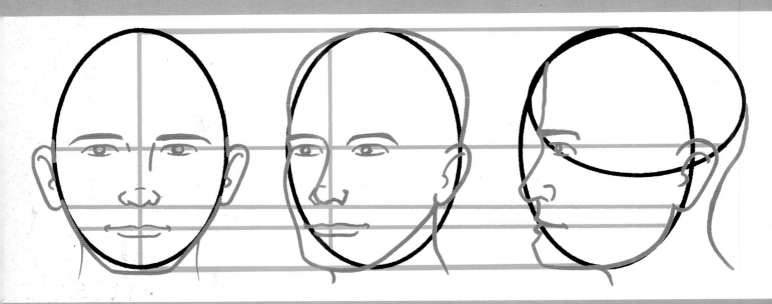

In order to discover how our character looks from different points of view, we first draw the face from the front and extend its guidelines across the page. Within these guidelines we can draw new starting shapes for a profile and a three-quarter view.

To show a three-quarter view, move the central line approximately halfway towards the side of the head and modify its shape, as shown, to create a more realistic outline.

For the profile view, add an overlapping oval to create the back of the head. For a realistic head, this oval should be no larger than that of your starting shape. Amend your starting shape along the edge of the face, as shown, paying particular attention around the chin and jaw. Notice also that the neck enters the head at an angle.

Use the guidelines from the eyes, nose, and mouth to accurately place these features onto the new starting shapes you've created.

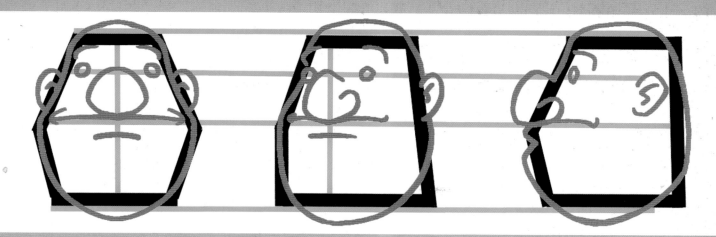

Exactly the same rules apply when we draw a more exaggerated or cartoony head, as shown below.

Sketch your starting shape for the head, and extend your guidelines off to the side to draw the character's facial features consistently from different viewpoints.

In the three-quarter view, notice that a cartoon character's eye can seemingly bulge over the edge of its face.

You need to think carefully about how the outline of a cartoony head changes when viewed from the side, taking your cue from your initial front-facing sketch. This character has a prominent nose and chin, so the starting shape for the profile is brought out to one side. The back of the head has been flattened and no neck is shown, emphasizing his pugnacious quality.

A couple more useful views of the realistic character – from directly behind, and a rear three-quarter view.

Moving the guidelines

Experiment with different shapes for the head and work out how, by moving the guidelines around as you begin, you can exaggerate the features of the face.

This vampire's wide face allows for a long, cunning smile. The woman's prim look is created by lengthening the space between her nose and her tiny, pursed mouth.

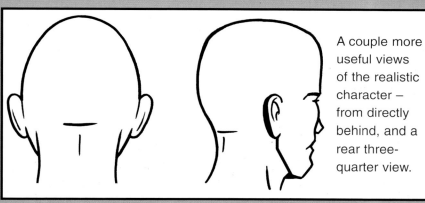

How do you think these characters might look from the side? Is the vampire's head shaped like a discus or a bean?

Don't overdo facial marks

When drawing younger people, keep lines that define creases and wrinkles to a minimum, as the more you add, the older your character will appear.

To depict ageing characters, add marks to the forehead, and around the eyes and mouth, but they shouldn't be as heavily drawn as your main outlines.

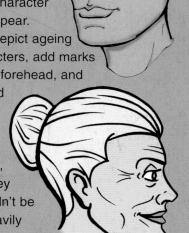

FACIAL EXPRESSIONS

To bring a lively quality to our characters' faces we need to show them displaying a range of emotions.

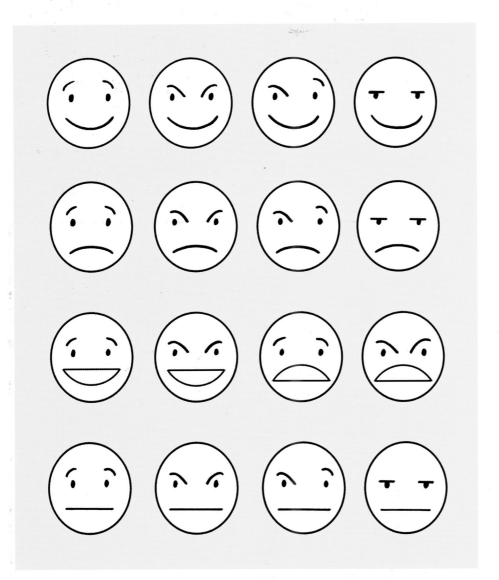

In these simple examples we can see that the position of the eyebrows, as well as the shape of the mouth, convey the feelings of a character. The same smile can look delighted or sinister, curious or smug.

A down-turned mouth can appear upset, annoyed, confused or grumpy.

By drawing the mouth open, emotions are intensified. By leaving the mouth as an impassive straight line, the eyebrows betray hidden emotions.

Some characters do not have visible eyebrows, so the cartoonist bends the ridges around the eyes to create the same effect. Often, the masks of super-heroes seem to bend and move, as though glued to the face.

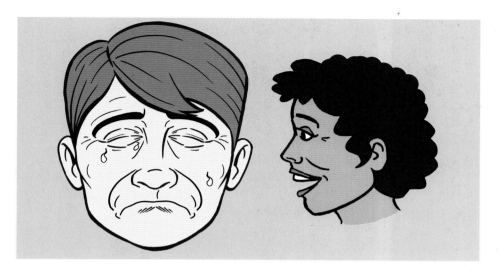

Realistic faces allow us to use all of their furrows and curves to display their emotions.

Humorous faces can make full use of massively exaggerated features, sometimes even doing things that are impossible in real life.

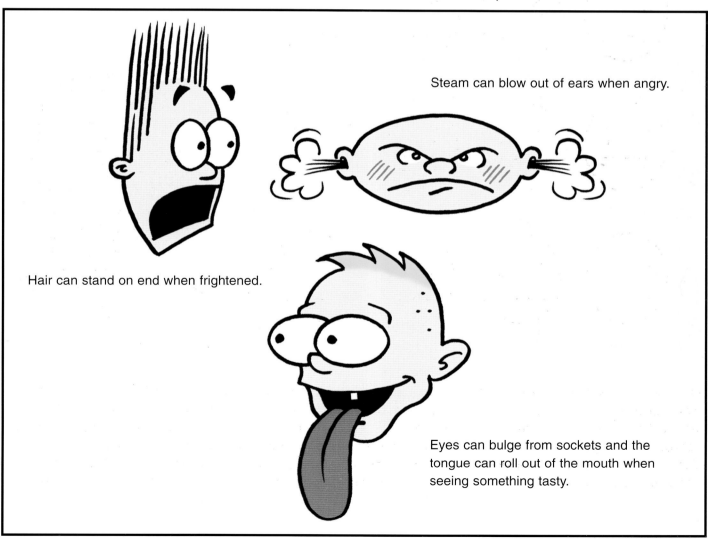

Steam can blow out of ears when angry.

Hair can stand on end when frightened.

Eyes can bulge from sockets and the tongue can roll out of the mouth when seeing something tasty.

FACE PROJECT

This exercise is designed to incorporate many of the techniques shown so far, to give you the opportunity to work as though from a professional assignment and practise your skills to perfection.

Families are a staple of cartooning, e.g. *The Flintstones, The Addams Family, The Simpsons,* etc. So, I'd like you to design the heads and faces of a somewhat typical family: father, mother, and son and daughter (aged about 10 and 12). Show each head from at least three angles and give each face an expression to indicate their general character: grumpy, friendly, scheming ... and they can be drawn in a realistic style or a humorous style, it's up to you.

Some pointers before you begin:

Perhaps your "family" share the same shape of nose or the same colour hair, or maybe the same expression? Elements such as these might visibly show that they are actually related to each other.

For characters drawn in a humorous, cartoony style, consider practising with different shapes for the head and by moving the guidelines around. Give yourself plenty of choices before settling on your favourite.

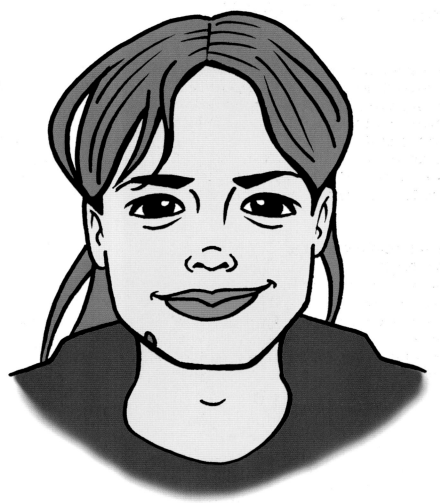

The likenesses of a realistically drawn family could be based on photographs of your own family and friends, or even pictures from magazines – they can all be used as an initial starting point for creating your own characters.

Take your time, look back over the preceding sections and remember that cartoon characters go through many revisions and refinements before they're presented to the world.

Overleaf you'll be able to assess your project by comparing your drawings to a selection illustrating common mistakes – these are based on examples I've personally encountered in students' early work.

FACE PROJECT ASSESSMENT

Hopefully, after long hours of thankless toil, you will now have managed to create your "family". I've been doing some drawing too, and I'm going to use these characters to illustrate some of the things that might have gone wrong.

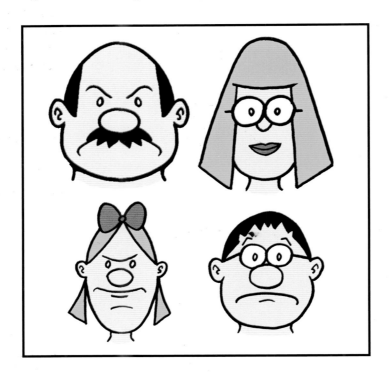

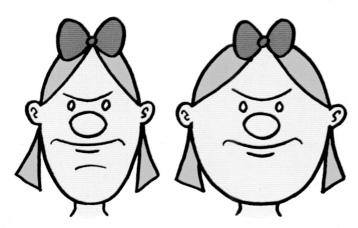

A common problem occurs when inconsistent shapes are used for the head.

It's important to practise the starting shape for a character's head many times over.

This was a well-thought-out solution to how the strange shape of Dad's head might look in profile, but, flushed with success, guidelines have been forgotten, and so the features are not in the correct place on the face.

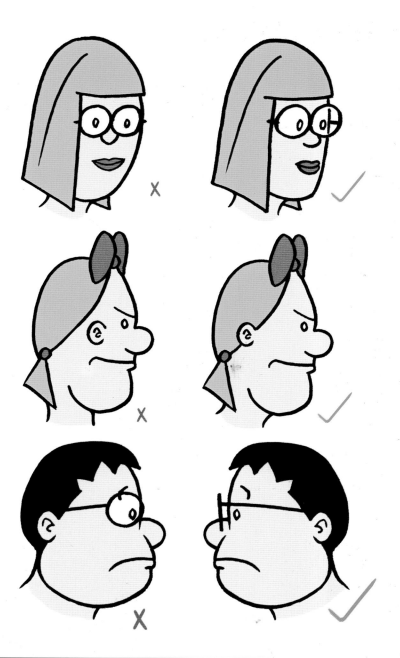

In this profile, although the central line has been moved across because the head is turned slightly, the face has been drawn looking directly toward us. Also, the shape of the chin has not been modified to take into account our different viewpoint.

Here, the ears have been drawn too far forward and the neck is too vertical; the corrected version looks much more naturalistic.

Remember that spectacle lenses do not look round or rectangular when viewed from the side.

Tips

When your character is speaking, lower the jaw, but keep the rest of the head in the same place.

Why not make a small bust of your character out of modelling clay? It'll enable you to see for yourself how its features look from different angles. And, for realistic faces, you can use a doll or an action figure for the same purpose!

FIGURE PROPORTIONS

We've seen how useful guidelines are when drawing the face - as we design bodies for our characters we'll find that preparatory under-drawing is virtually essential.

Our first step must be to decide on the proportions of our figure - the relative size of the head, arms, legs and body. Our proportions change as we grow from children to adulthood, but cartoon adults may be given the proportions of children, and animals may be drawn larger and with different proportions to those in real life.

The head as a unit of measurement

Artists tend to use the head as a unit of measurement for the body, and here we can see the most commonly used proportions for different types of figure. Notice that no matter how outlandish the proportions, arms are normally drawn as long as the inside of the leg, mirroring the proportions of real people. When the arm is at rest, the wrist generally falls level with the crotch, though this can be modified with exaggerated characters such as the 2- and 3-head characters below.

2 heads – usually used for drawing small children or anthropomorphous animal characters.

3 heads – again, often used for children or funny animals.

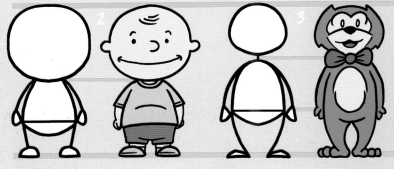

The proportions we use need have no bearing on the height of our characters. A 3-head figure can be used to draw a messy child … or an angry giant.

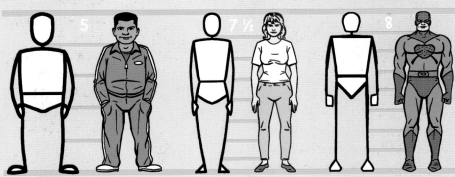

5 heads – suitable for teenagers, animals, and humorously drawn adults.

7½ heads – these are the realistic proportions of an adult human.

8 heads – commonly used for super-heroes and other larger-than-life characters.

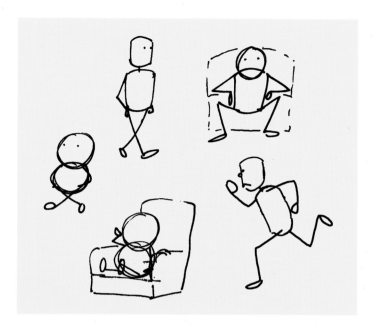

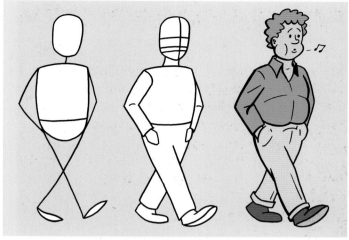

Proportions in poses

When you've decided on the proportions of your character, try drawing stick-figures in a variety of poses. Practise keeping the relative sizes of each part of the body the same. Only then are you ready to turn these simple sticks and shapes into fully rendered cartoon characters.

Beginning with a simple stick-figure drawing enables us to quickly pose our character and it's easy to erase if you change your mind. We can then flesh out our character before adding the details, inking the drawing and erasing any remaining pencil marks.

Common mistakes

Here are some common mistakes to watch out for:

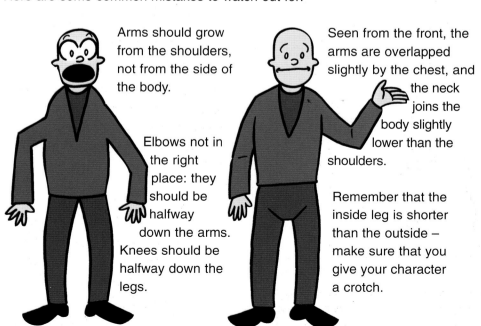

Arms should grow from the shoulders, not from the side of the body.

Elbows not in the right place: they should be halfway down the arms. Knees should be halfway down the legs.

Seen from the front, the arms are overlapped slightly by the chest, and the neck joins the body slightly lower than the shoulders.

Remember that the inside leg is shorter than the outside – make sure that you give your character a crotch.

Note that from the side-view, the neck grows out of the back at a slight angle; the arms are drawn covering the rear half of the body on an average person.

When you've mastered these techniques, you can tackle the next few pages.

ANTHROPOMORPHOUS* ANIMALS

*"...RESEMBLING A HUMAN BEING" – CHAMBERS DICTIONARY

There is a tradition in cartoons and comics of animals that walk and talk as though they were human. Perhaps the idea comes from those animal-headed figures seen in ancient Egyptian artwork, or the Graeco-Roman myths of the Minotaur and other fabulous beings.

Tom & Jerry, Mickey Mouse, Yogi Bear, Daffy Duck, Ren & Stimpy, and their brethren, all walk on their hind legs, live in houses and even wear clothing. These characters can be drawn in much the same way as regular human figures, but with one or two important distinctions.

Most animals have some form of snout, which must be taken into account when we design the head and face of our characters.

The length of the snout should reflect that of the actual animal.

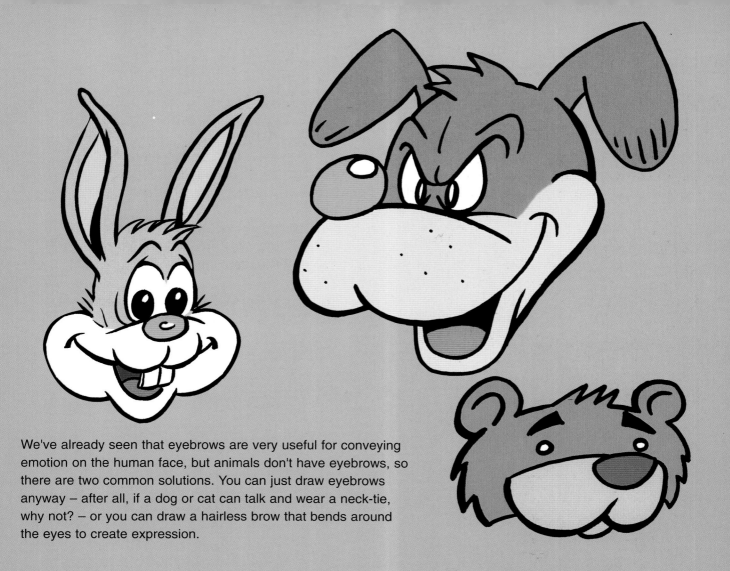

We've already seen that eyebrows are very useful for conveying emotion on the human face, but animals don't have eyebrows, so there are two common solutions. You can just draw eyebrows anyway – after all, if a dog or cat can talk and wear a neck-tie, why not? – or you can draw a hairless brow that bends around the eyes to create expression.

The bodies of most "funny animals" tend to be drawn in proportions between 2 and 5 heads.

Other obvious differences to take into account are that these characters might have big ears, a tail, etc., but otherwise they tend to conform to the basic principles of the exaggerated human figure.

MUSCLES MADE SIMPLE

For those who might be interested in drawing super-heroes and other similarly muscle-bound characters, these pages offer a guide to the basic muscle forms of the human figure. For more detailed information, you'll need to consult a specialist book on drawing super-heroes (of which there are many available), look at books on human anatomy or examine the photos in body-building magazines. You might also consider enrolling in any part-time life drawing classes in your area. However, the simplified methods shown here should give you a head start in tackling this complicated but rewarding area of cartooning.

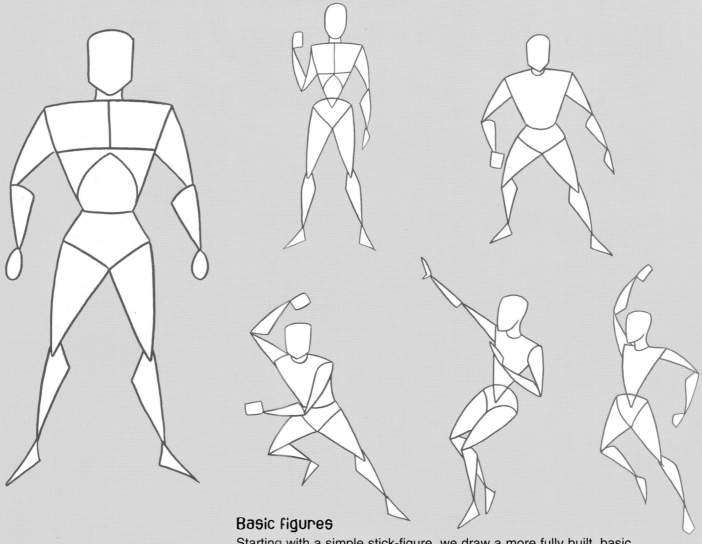

Basic figures

Starting with a simple stick-figure, we draw a more fully built, basic figure, as shown.

Notice that the male figure tends to be drawn more broadly than the female – even if she's more powerful – a standard feature of super-hero comics.

At this stage, it's worth spending some time practising drawing the figure in a variety of poses, to get used to how the basic shapes bend and overlap.

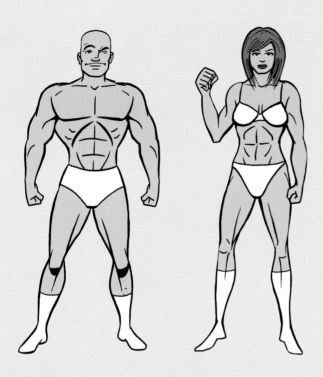

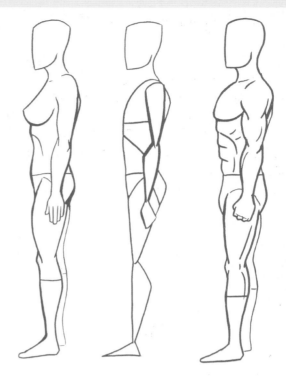

Defining muscle form

Our next step is to define the muscles more clearly. You can examine illustrations, photos or a well-developed friend for reference. These illustrations show the main muscle forms, but you can draw in more detail, or less.

A simplified version of the muscular figure was much in vogue in comic books and animation during the late 90s/early 00s.

Different views

Obviously, you won't want to constantly draw your figure from the front, unless you're drawing "Front-Facing Man", so here's how a sideways-on muscular figure can be constructed from a similarly simple basic drawing.

And here's a general rear-view showing the basic contours of a muscular back.

Hopefully, these pointers will get you started if you're particularly interested in drawing pictures of people punching each other in the name of justice!

Revealed at last! Why super-heroes wear their underpants on the outside of their tights!

The classic super-hero costume is based on the outfits worn by circus strongmen in the early 20th century. These guys needed to show off their muscles, even in cold temperatures, so they wore tights and capes – to add to their wacky showmanship. Unfortunately, in the days before elastic or Lycra, the crotch of their tights would be prone to split as they performed their

daring feats! Consequently, they took to wearing a pair of shorts on the outside, to conceal their sudden dangling appendages, should such an accident occur … and inadvertently, a cliché of comic books began. So now you know …

CLOTHES AND COSTUMES

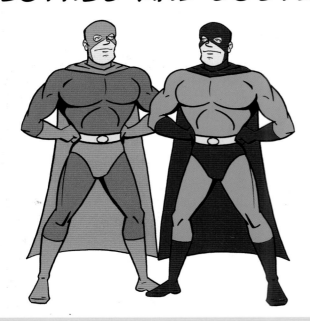

Cartoon characters tend to be drawn wearing the same clothing each time they appear and distinctive elements are considered essential.

Charlie Brown, for example, is instantly recognizable by the zigzag pattern on his shirt, Tintin by his old-fashioned knee-length trousers, and Top Cat by his hat and waistcoat. Super-heroes are identified by the colours and patterns on their form-fitting costumes, enabling us to instantly spot who's who in any picture.

Even if your characters will not reappear, such as those used for a one-off illustration, it's important to dress them appropriately.

Stereotyping

Humorous cartoonists tend to apply a certain amount of visual stereotyping as a kind of shorthand to quickly communicate the role of their characters.

Judges wear a wig and gown, while burglars wear a striped pullover and a little black mask.

Butchers wear a straw hat and a striped apron.

Teachers are still often shown wearing a gown and mortarboard, even though they have long disappeared from use in schools.

Some of these are anachronistic clichés, but even in the 21st century they remain powerful visual symbols.

Creasing

It's important to remember that regular clothing creases when the elbows and knees bend. Here we can see the main creases at these points, drawn in a realistic manner and in a less detailed, cartoony fashion. Also shown is the view of bent knees seen from the front.

The slighter creases in a woman's dress are normally only drawn in realistic cartoons.

HANDS AND FEET

The simplest way to draw hands is to start with a mitten shape and then divide it into fingers.

More realistic hands can be built up from a pentagon.

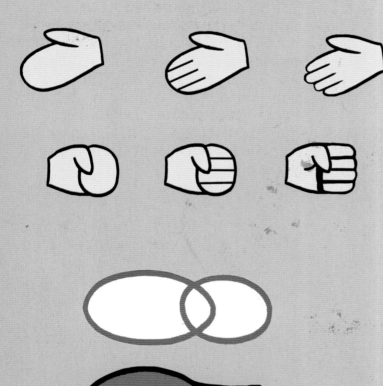

Simple cartoon feet can be drawn around the shape of two beans.

To draw realistic feet, we can begin with a bean and a wedge shape, and then modify accordingly.

When we view feet from the front, we normally see a slightly foreshortened version of these shapes (see pages 48–49).

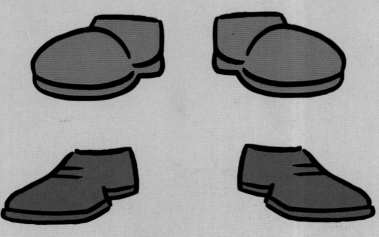

THE MOVING FIGURE

So far we've been drawing standing figures, but unless we're going to be presenting entertaining tales of people in a queue for a bus, we'll need to draw the figure in movement as well as at rest.

Using your X-ray vision, look closely at the figures on these pages and you'll see the simple stick-figure over which they were drawn.

It's the curvature and direction of the spine that can illustrate a sense of urgency, relaxation, tension or calm, and exaggerate an impression of strength or emotion.

Lightly sketch your own stick-figures and build your character over the top.

Try variations of the poses here: different ways of running, sleeping, flying ... come on, you don't always fly like that, do you?

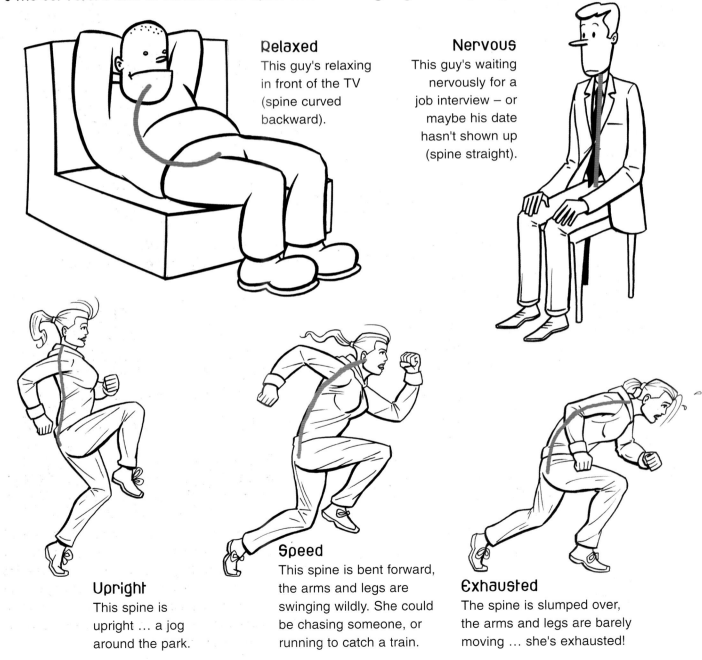

Relaxed
This guy's relaxing in front of the TV (spine curved backward).

Nervous
This guy's waiting nervously for a job interview – or maybe his date hasn't shown up (spine straight).

Upright
This spine is upright ... a jog around the park.

Speed
This spine is bent forward, the arms and legs are swinging wildly. She could be chasing someone, or running to catch a train.

Exhausted
The spine is slumped over, the arms and legs are barely moving ... she's exhausted!

Intent

Mr Left has come up with an evil plan, but Mr Right's plan is even sneakier … what's the difference between their similar poses?

Impact

This hero is punching a bad guy …

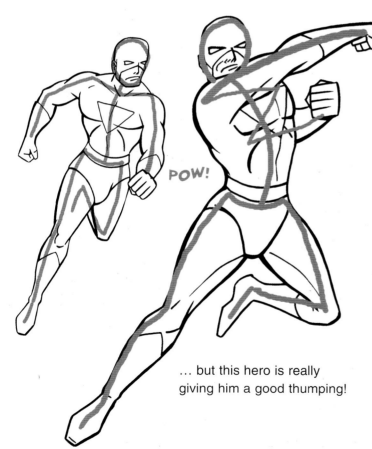

POW!

… but this hero is really giving him a good thumping!

Reaching

Which cat looks like it'll catch the fly?

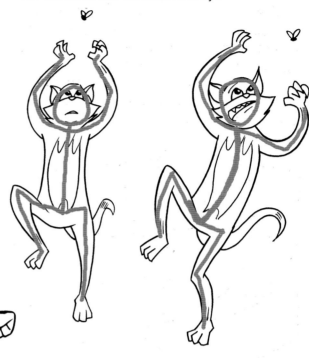

Confidence and dejection

Which of these cowboys is unlucky at cards?

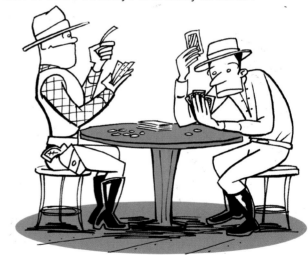

In your idle moments (such as relaxing in front of the TV, nervously waiting for a job interview, or just catching a fly!), doodle some stick-figures sitting, walking, leaping, running, fighting, tossing an omelette, anything you can think of, and try bending the spine in different ways. You might be surprised at the range and versatility such a simple technique can give you!

FORESHORTENING

Virtually any object, when tilted forward, appears
to get shorter.

At a tilt of 60 degrees, an object will appear to be half
of its original length.

The sides will also appear to taper inward as the end
that's furthest from our eyes appears smaller ... or the
end that's closest appears to be larger than the rest of it.

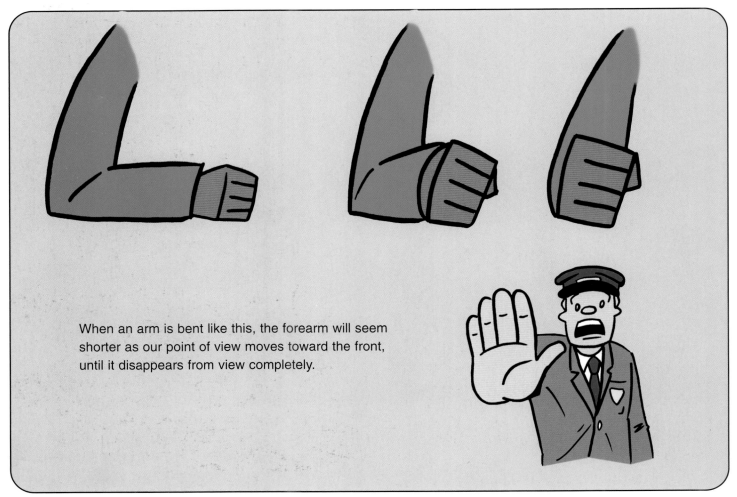

When an arm is bent like this, the forearm will seem
shorter as our point of view moves toward the front,
until it disappears from view completely.

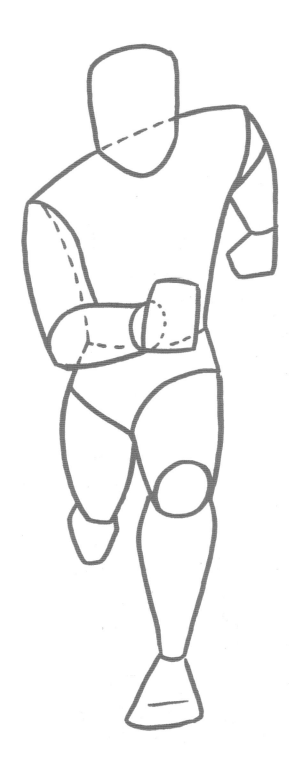

Similarly, when viewed from the front, a seated figure will seem to have no thighs, due to the same optical illusion shown in the illustration of the bent arm.

Foreshortening is a useful device for conveying a sense of depth in your pictures, but you'll need to practise to get it right.

The left arm of this running figure is tilted so far back that its upper part appears so short it has almost disappeared. The right lower leg is tucked behind the thigh and, again, is foreshortened to the point of invisibility. Only the tip of the foot can be seen as it drops slightly lower.

FIGURES PROJECT

Earlier, we designed the faces of a family of cartoon characters. Now, we're going to design their bodies.

Start with a stick-figure

Remember to start with a simple stick-figure and decide on the proportions for each family member.

Will they all be of the same proportions but of different height?

Or will they be of different height and of different proportions?

Try a few alternatives before you make up your mind.

What clothes will they wear?

Next, try to imagine what kind of clothes these characters will usually wear.

Smart? Casual? Some kind of costume, perhaps – they could be a family of pirates, or cavemen?

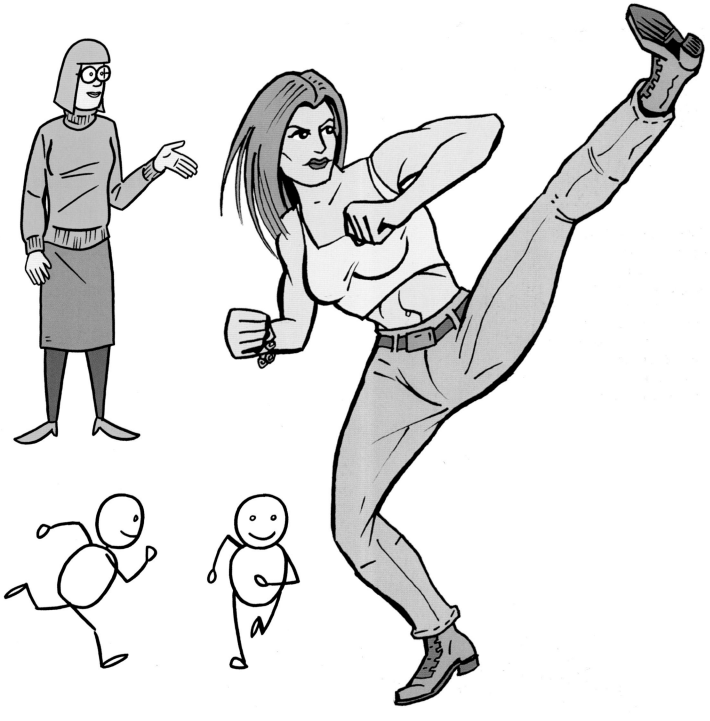

How will they move?

Finally, let's see these characters moving around:
walking, running, sitting, etc … and let's see them
doing these things from more than one angle.

Remember to foreshorten limbs where necessary.

Take your time, look back at what you've learned, and
practise, practise, practise!

FIGURES PROJECT ASSESSMENT

Hopefully, you've managed to create a fully mobile family whose proportions are consistent in each picture ... but let's examine some common problems.

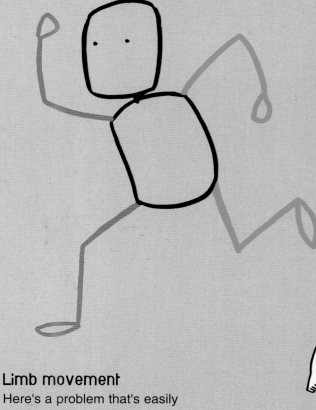

Limb movement

Here's a problem that's easily spotted and amended at the stick-figure stage. When we run, the opposing arms are forward and backward of the figure, not in line as shown here. It's how we keep our balance, and if you try running like this stick-figure, it'll feel very strange indeed.

Short arms

Dad's arms are too short compared with the rest of his body. There are too few cartoon characters with disabilities, but unless this was your intention, remember to keep your characters' arms as long as their legs.

Movement proportions

Another common problem with running characters is when they're drawn with the knee at the same level as the opposite foot ... she'd be bumping her knees on the floor – very painful!

Sitting proportions

Here we can see what happens when the thighs of a seated figure are not foreshortened – he looks as though he's uncomfortably crouching in front of the armchair. Next, we can see how it should look – remember that a boy's feet might not quite reach the floor when he's sitting.

Don't worry if you've found some of these mistakes in your own early efforts – virtually everyone encounters a few problems as they begin to master drawing the figure.

Just for fun, why not try drawing a family of cartoon animals?

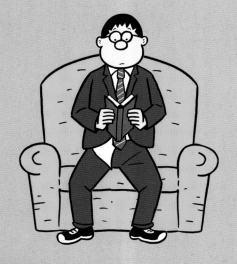
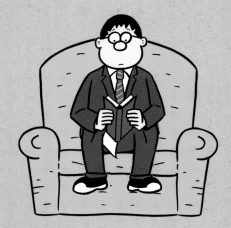

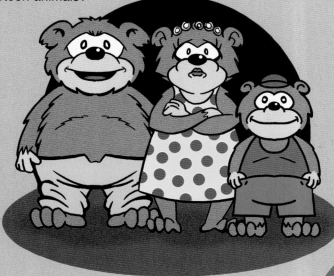

A word of caution!

Many art shops sell wooden figures designed to help artists to draw bodies in different poses. However, they are not usually fully "poseable". Some children's dolls and action figures have more points of articulation and can be considerably cheaper to buy. Also, of course, you can buy clothes for them, making them even more useful. And you can play with them when no-one's looking!

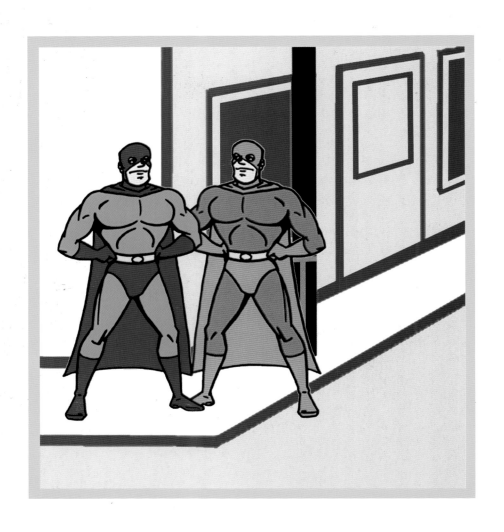

Chapter 3:

PLACES AND OBJECTS

BASIC RULES OF PERSPECTIVE

In this chapter, we're going to take a look at how we can draw settings and backgrounds for our characters using some of the simple rules of drawing in perspective.

These techniques are designed to help us to create a world for our characters to inhabit that resembles the real world around us.

Viewing the scene

Our first step is to understand the principle of the "eye-level".
Simply, this means "from where we are viewing the scene".

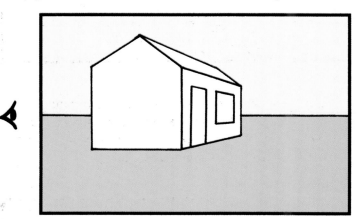

Our first picture shows a house viewed as though we are standing on the ground, and our eyes are level with the top third of the door.

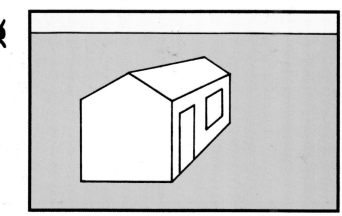

In our second picture we see the house from above, as though we are flying or looking out from a taller building – a "bird's-eye view".

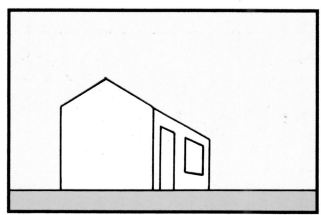

The third picture shows the house as though our eyes are right down at ground level – a "worm's-eye view".

The eye-level is drawn across the picture to become the horizon.

In art, as in life, there can only be one eye-level in a picture, unless you're built like this crazy alien.

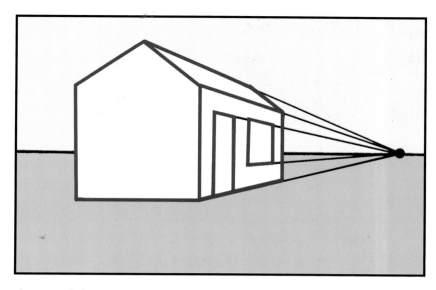

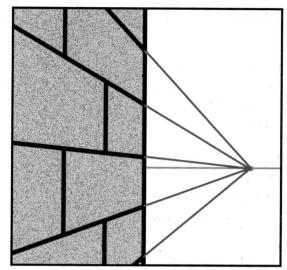

One-point perspective

The edges of the roof, the top and bottom edges of the door and window, and the base of the house all point to the same point on the eye-level. This is known as the "vanishing point", and objects drawn in this way are said to be drawn in "one-point perspective".

One-point perspective helps you to correctly align many elements of the picture, such as brickwork ... it also helps us to draw people and objects at the correct size as they appear to stand further away.

More than one vanishing point can be used for separate objects in the same picture. The central house is obscuring its own vanishing point, as we are looking at it directly face-on.

This can all seem quite complicated at first, but you'll find it actually quite simple with practice.

Before moving on, try and draw a very simple house in one-point perspective, and then add a couple of stick-figures – one in the foreground and one further back.

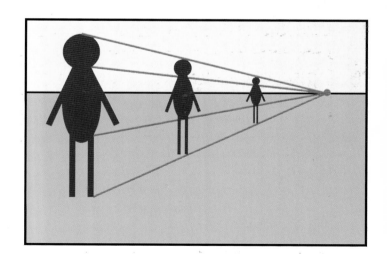

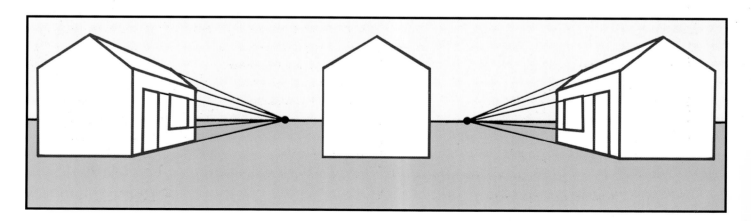

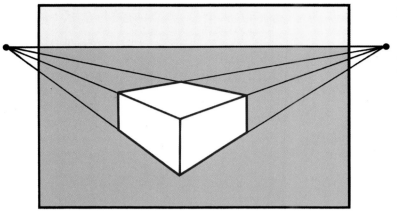 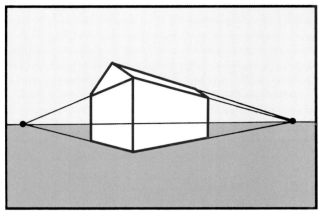

Two-point perspective

A different view can be achieved using two vanishing points for each object – two-point perspective. This effect works best if the vanishing points are at the extreme edges of your picture, or even completely outside.

When drawn in two-point perspective, all the horizontal edges of an object are slanted toward a vanishing point. Vertical edges remain vertical.

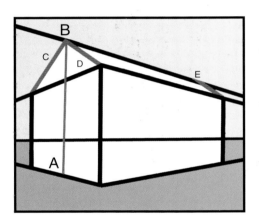

The sloping roof of this house is drawn correctly by drawing a vertical

Line (A) through the middle of the wall up to the top edge of the roof (B). From this point, lines (C & D) are drawn down to the corners of the house. The furthest side of the roof (E) is drawn in a parallel direction to the closest edge (D).

Give it a try, you'll quickly find that it's not as difficult as it can first appear. Virtually any object – buildings, furniture, vehicles, etc, can be drawn using simple cubes drawn in perspective.

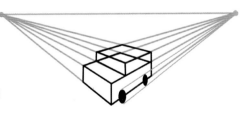

Here's a very simple car drawn using two cubes, one atop the other, drawn in two-point perspective.

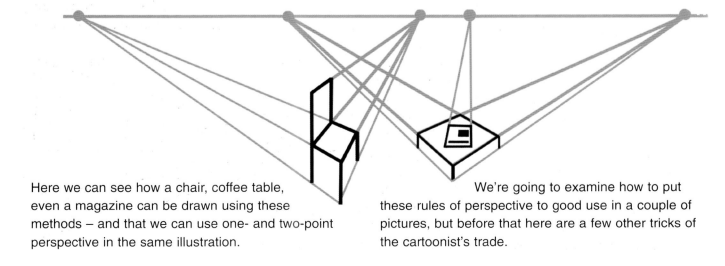

Here we can see how a chair, coffee table, even a magazine can be drawn using these methods – and that we can use one- and two-point perspective in the same illustration.

We're going to examine how to put these rules of perspective to good use in a couple of pictures, but before that here are a few other tricks of the cartoonist's trade.

Tricks of the trade

Three-point perspective enables us to emphasize great height or depth, as the vertical sides of these tall buildings appear to be converging at a third vanishing point in an arbitrary area above or below our pictures, depending on our chosen view. This can be fun to try and is often used in super-hero comics, but for general cartooning purposes it's rarely necessary.

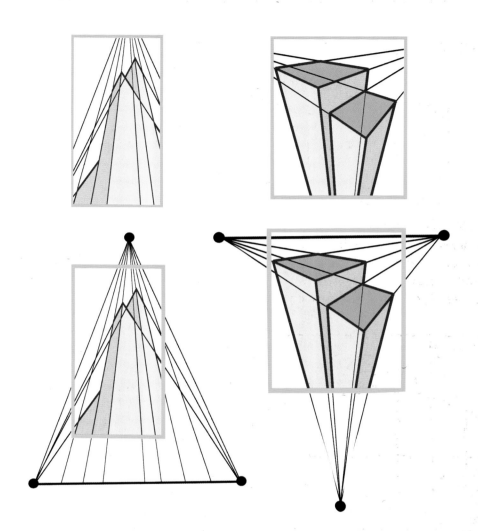

Circles become ovals when drawn in perspective. Using your vanishing point, draw a rectangle the same size that you'll need to show your circle.

Find the centre by drawing lines from corner to corner, and where they meet in the middle, draw vertical and horizontal lines. Use these as a guide for sketching your oval. Or, get one of your oval templates and see if there's one that fits neatly within your rectangle.

The width of objects in a row, or the space between objects, should appear to decrease when drawn in perspective. If this level of accuracy is important to your drawing, we can see here how it's done.

Divide your area along its closest vertical side, and rule lines through to the vanishing point. Draw a diagonal line across the area, as shown, and where the lines connect, vertical lines will divide the area into sections of correctly diminishing width.

These techniques are unavoidably tedious, but with practice they can enhance your cartoons immeasurably, as we are about to discover.

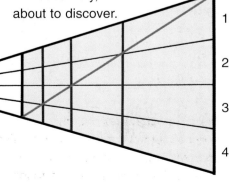

INDOOR SCENE

Taking a look at a typical interior, we're going to examine how one-point perspective can help us to draw a simple view into the corner of a room.

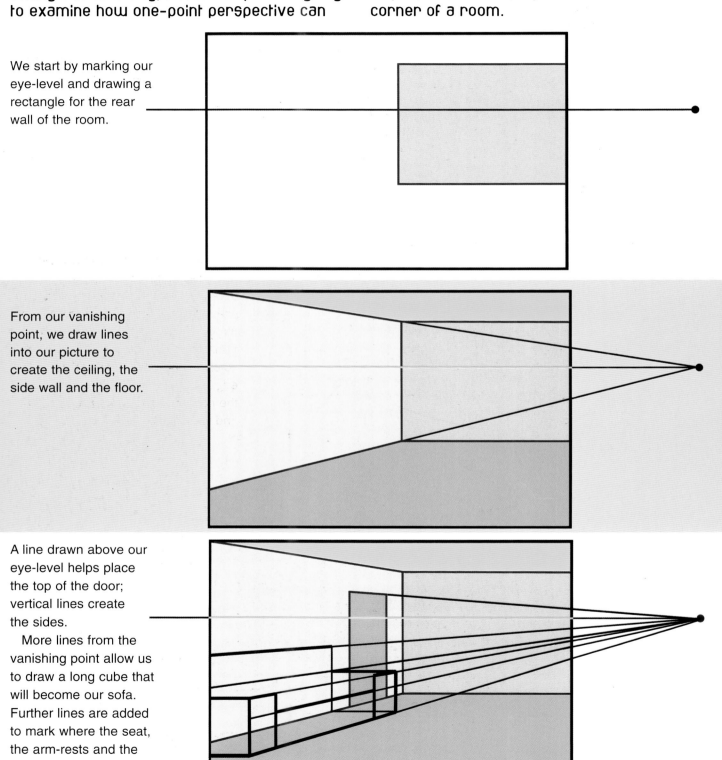

We start by marking our eye-level and drawing a rectangle for the rear wall of the room.

From our vanishing point, we draw lines into our picture to create the ceiling, the side wall and the floor.

A line drawn above our eye-level helps place the top of the door; vertical lines create the sides.

More lines from the vanishing point allow us to draw a long cube that will become our sofa. Further lines are added to mark where the seat, the arm-rests and the back of the sofa will be.

A few more
lines allow us
to construct a
simple but
realistic sofa.

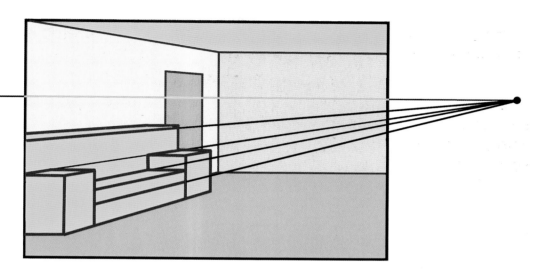

For a little variety, the coffee table
has been drawn in one-point
perspective from a different vanishing
point. A window can be added just by
using horizontal and vertical lines –
remember that in pictures illustrated
solely in one-point perspective, all
edges that are NOT pointing toward
the horizon are drawn as horizontal
and vertical lines.

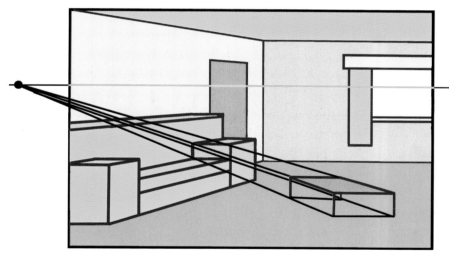

And hey presto!
A basic lounge,
drawn in one-point
perspective.

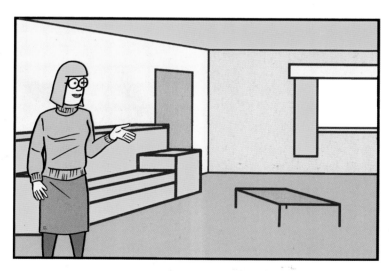

OUTDOOR SCENE

Here's how we can begin a drawing of a street corner using two-point perspective,

and a few of the other techniques that we looked at earlier.

Draw your eye-level and then cross it with a vertical line – this will be the corner of our buildings. Join this vertical line to two vanishing points to create their sides.
 Vertically divide your buildings wherever you like and then draw lines below, from the vanishing points, to mark out where we'll have the pavement and the road.

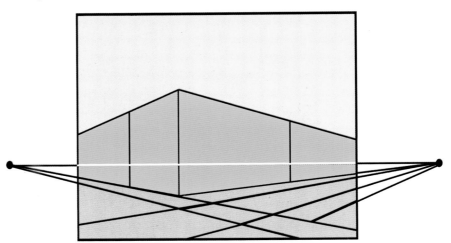

Next, we're going to add windows to our buildings. Divide the closest corner edge into the divisions you'll require – here we have alternate wide and narrow divisions for windows and brickwork. Draw lines out to the vanishing point, as shown, and then lightly add a diagonal line across the front of each building.

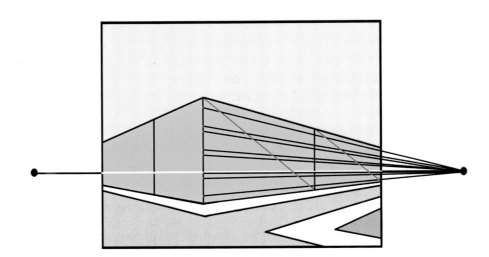

Where the lines to the vanishing point cross the diagonal line, draw vertical lines to create our windows.

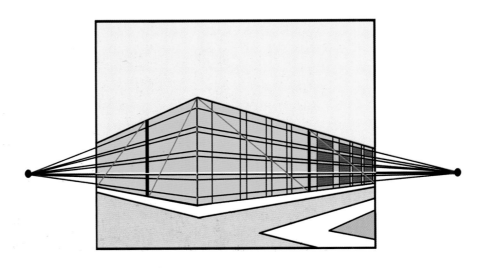

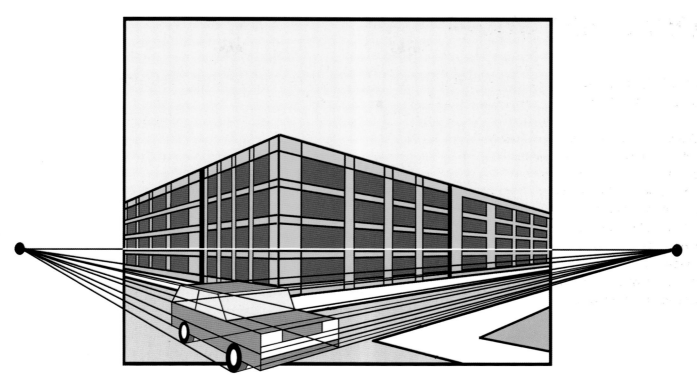

We could use two new vanishing points to draw the car, but as it should be driving in line with the kerb, it makes sense to stick with the ones we've been using. Construct a simple car in the manner shown earlier, using two cubes (see page 58), and make sure you use guidelines from each vanishing point to keep the wheels, headlights, radiator, etc, in perspective.

This basic frame can be modified into any style of vehicle you wish, by using photographs as reference.

And here's our simple street. Now you can go ahead and add some extra detail – lamp-posts, telephone poles, more vehicles, some people, a rampaging dinosaur … just remember, as always, to start with basic shapes.

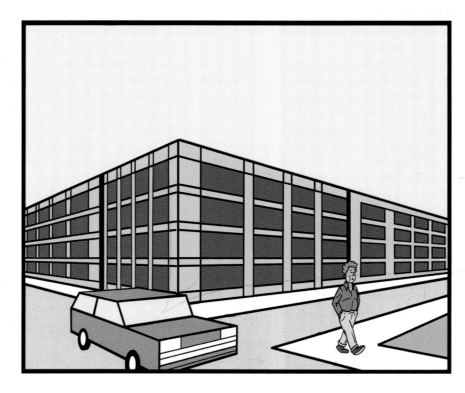

PERSPECTIVE PROJECT

I recommend re-reading the last few pages and attempting some of the simple "building-blocks" and views, before embarking on this project. It's tricky stuff, but practising these steps will vastly improve your drawing skills.

We've already seen step-by-step methods of drawing a lounge in one-point perspective, and a street in two-point perspective. Both types of perspective are equally useful, so let's mix and match.

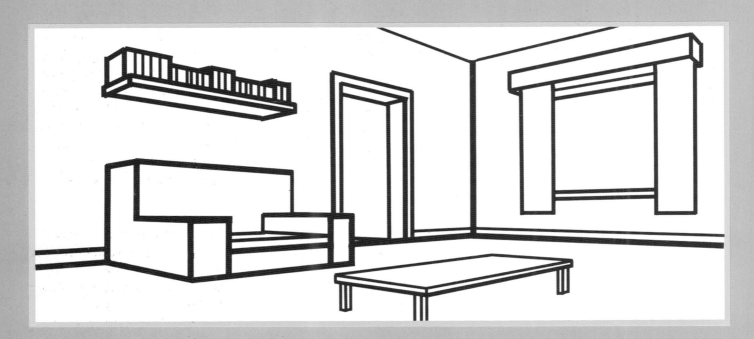

Lounge scene drawn in two-point perspective

Here's a lounge drawn in two-point perspective, and the same scene showing just the eye-level and the basic directional lines that were used to begin the picture. From this simple outline, see if you can copy the finished version. As an added guide, note that the edges of all objects that are aligned parallel to lines A and B should extend to Vanishing Point 2; those aligned with lines C and D should extend to Vanishing Point 1. All vertical edges remain strictly vertical – straight up and straight down.

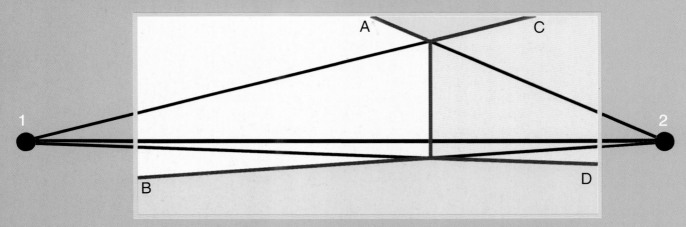

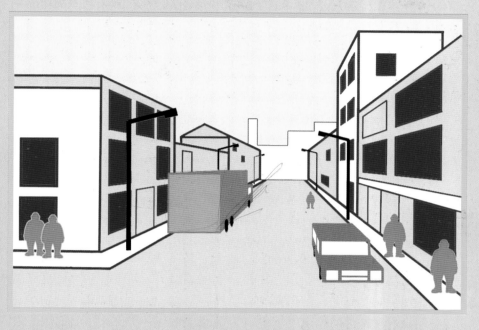

Street scene drawn in one-point perspective

This street scene, complete with lamp-posts, simple vehicles and people, is drawn using one-point perspective. The windows, lamp-posts and people have all been spaced and re-sized correctly using the methods shown earlier. All sides facing us are drawn just using vertical and horizontal lines; only those edges heading away from us into the picture are drawn toward the vanishing point.

The vehicles are constructed from cubes and – far in the distance – other tall buildings are drawn as a simple outline.

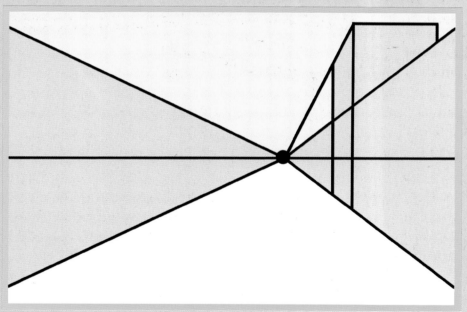

And here we can see the eye-level and directional lines that were used to begin this picture. So, again, see if you can use them to copy the finished version shown. Concentrate on the main outlines of the significant elements of the picture, but don't draw every single detail of the buildings that are furthest away, or else you'll go mad.

Allow plenty of time for this – it's not easy – but with these skills you'll have mastered drawing faces, figures and places – the three key aspects of successful cartooning.

PERSPECTIVE PROJECT ASSESSMENT

Congratulations on attempting the trickiest technical exercises in this book! Hopefully, you've managed to achieve reasonable results, but if things don't look quite right, take a look at these examples of common mistakes.

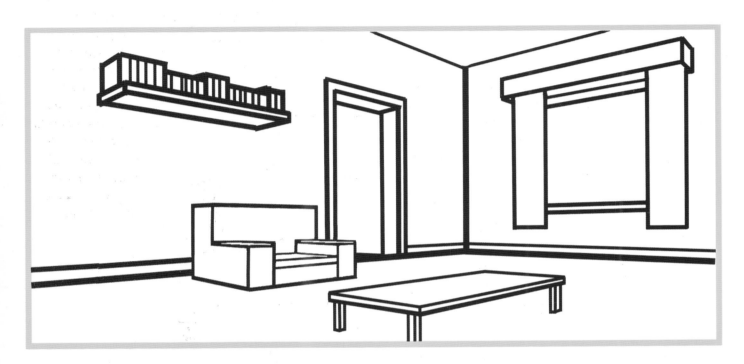

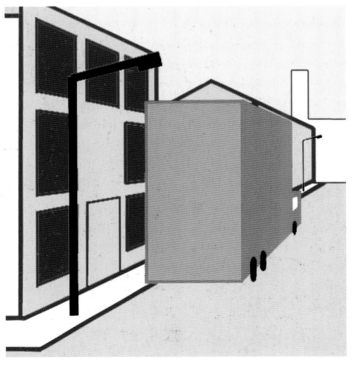

Proportions are important

At first glance, there appears to be nothing wrong with this picture. But compare the size of the sofa with the doorway next to it. The average doorway is about 2 metres high, so in this picture the sofa is only about 60 centimetres (2 feet) high, which is far too small.

Here's the opposite version of the same problem. Compared to the building, the lorry is two storeys high, much bigger than it would be in real life.

It's important to use each element of a picture as a gauge for measurement. A sofa should be about half as tall as an adjacent doorway; a lorry is usually a little over one storey high.

Work out the correct vanishing points

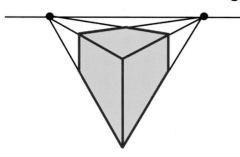

This is what can happen if you are drawing in two-point perspective and you use vanishing points that are too close together – objects look too squashed up. Always try to use vanishing points that are far apart, even outside the picture frame if possible.

In this picture the top of the doorway has been drawn toward the wrong vanishing point.

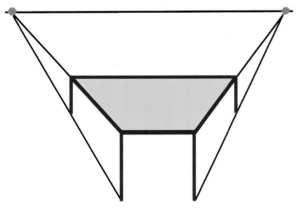

All the parallel edges of an object like this table and the alignment of its legs should always be drawn to the same single vanishing point – otherwise your results might end up like this.

As mentioned above, these are common mistakes – everyone makes them at some point.

Perspective in cartoons

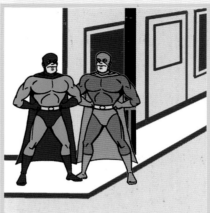

Finally, let's take a look at how perspective is commonly used in cartoons. After all, you're not going to need to draw panoramic views every time. Nevertheless, all of the background lines are drawn to vanishing points on an eye-level, often far outside the actual borders of the panel.

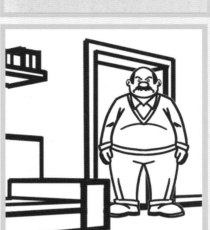

Partially turned figures

Here's another way that perspective is commonly used, in a fashion that's so subtle you might not notice. A partially turned figure should be slightly drawn in perspective, to a vanishing point that would be so far off the page it might be physically impossible to accurately render. So, most artists cheat, making one side of the body just slightly shorter than the other – but it's cheating based on a sound knowledge of perspective – knowledge you now possess.

ESTABLISHING AN ENVIRONMENT

We've seen how to use perspective to create interior and exterior scenes, so let's look at what essential elements we should consider putting in those scenes in order to define a sense of place, allowing the reader to quickly determine our characters' location. The amount of detail required can vary according to the style and subject matter of your cartoon a real-life location such as a famous building can necessitate working from photographic reference. Some artists carry a small sketchbook around so that they can do rough sketches of different places they visit. The small digital cameras in cell phones can be used to archive photographs on a home computer. These are all convenient ways to build a reference library of images from which you can pluck the vital elements of any scene or setting, but most places can be fairly generic, sharing common typical features.

Interior scene dressing

Often, the addition to a scene of just a little extra dressing will suffice to show where the action is taking place:

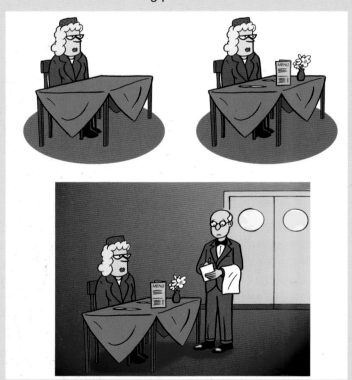

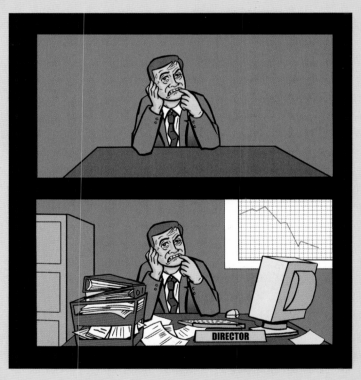

A person sitting at a table could be at home – add a menu to the table and swing-doors with round windows in the background, and it's a person sitting in a café; add a waiter, and it's a restaurant.

A person at a desk could be almost anywhere – add a computer monitor and keyboard, papers on the desk and a filing cabinet nearby, and it becomes an office. If there's a chart on the wall with random letters of decreasing size, it's an optician's office; framed newspapers on the wall will show that it's a newspaper's office; a large graph on the wall with the word "Sales" should indicate that it's a business office.

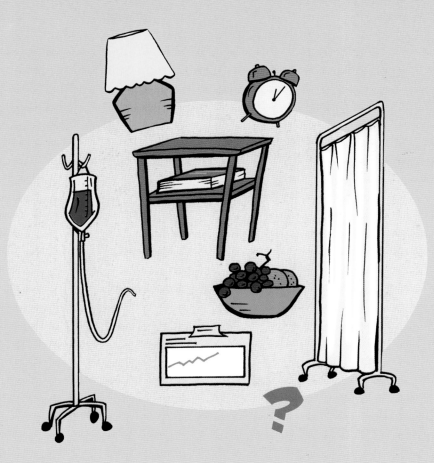

If we see a person lying in a bed, what three or four items could you add that might indicate that they are either in hospital or relaxing in their bedroom?

Exterior scene dressing

The same applies to exterior scenes. If called upon to set a cartoon in a city street, what we choose to show can indicate whether it's part of the business district (office blocks, a wine bar, restaurants, clean walls and pavements) or a more run-down area of the town (derelict buildings, scruffy bars, graffiti and litter).

Establishing an environment need not be back-breaking toil as long as you concentrate on including the most significant features of a particular location.

POINTS OF VIEW

With cartoons, as with any other kind of visual art, we can control how involved the viewer is with the scene that we present. Obviously, distance is a deciding factor.

Inclusion or watching from the sidelines?

Here we can see two boys playing football. Our point of view is that we are up close with them, perhaps even playing the game ourselves – we feel involved with the scene.

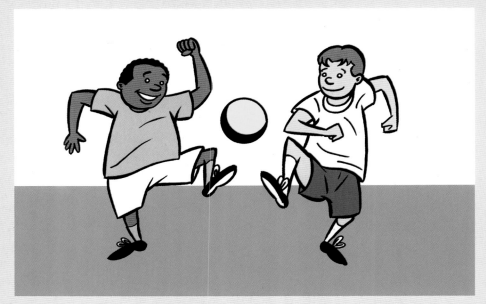

From further away, we feel less involved, we're watching from the sidelines. Whatever those lads do won't have an immediate effect on us.

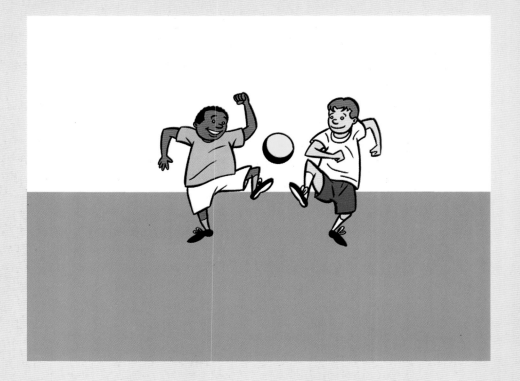

Eye-level plays a part

Another key factor is our choice of eye-level. Here's a typical "Waiter, there's a fly in my soup!" scene. See how our emotions are toyed with by the use of differing eye-levels.

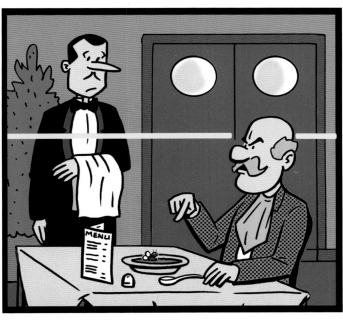

In this picture, our eye-level is that of the customer, as though we were sitting at the next table. We share his consternation.

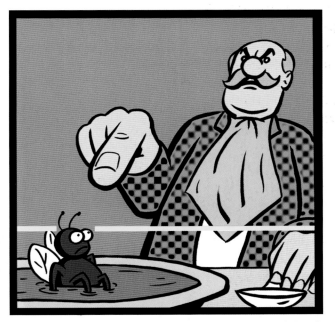

In this picture our eye-level is down with that of the fly; the customer now seems quite menacing as he towers above us. We are led to empathize with the fly.

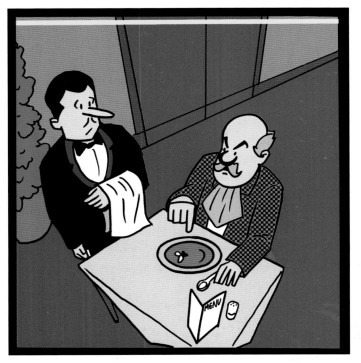

With the eye-level up above the scene, we view it dispassionately; we are out of harm's way; every character in the picture is beneath us. We don't feel involved with any of them.

Cartoonists frequently change points of view in sequential strips, but it's worth bearing in mind the empathic possibilities of each angle.

When we use the lower or higher eye-levels, we must use a third vanishing point above or below the picture in order to portray the customer towering above the hapless fly, or to show the outlines of furniture and figures receding downwards from our viewpoint. Confused? Refer back to Tricks Of The Trade on page 59.

SINGLE PANEL PROJECT

If you've diligently practised as we've progressed through this book so far, you should find yourself with the basic skills necessary to the cartoonist - able to draw faces and figures that illustrate a range of emotions and activities, and able to draw a part of the world around them.

Let's pull it all together and attempt a couple of single panel gags, such as you'd find in a newspaper or magazine.

Single panel 1

Our first takes place in a restaurant, where a waiter is reading to a customer from a menu:

Waiter: "I've got Pig's Feet, Chicken Legs and Boiled Tongue."
Customer: "Don't tell me your problems – just get me a coffee!"

The waiter's expression should be fairly blank, in contrast to that of the customer who should look rather cross and impatient. Perhaps the customer is waving his or her hand dismissively, or angrily pounding the table. Feel free to make the waiter a waitress.

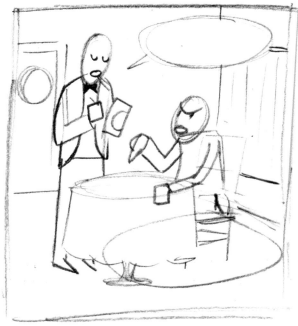

We'll need to see the table with a tablecloth, possibly a number of chairs, and other background details to suggest the right environment.

You'll need to decide from what point of view we're viewing the scene. Are we meant to be sitting at the table, standing next to the waiter, or viewing the situation from another table nearby?

Where should we place the word balloons so as not to obscure any important details?

Should we draw this using one-point perspective or two-point perspective?

Try out a few options as small rough sketches (known as "thumbnails") before you decide.

Single panel 2

Our second picture requires a different setting: an office with a person sitting at a desk. He or she is holding a telephone and leaning down to rummage in a waste-paper bin:

"Just a moment, Sir, I'll see if it's in my special file …"

The office worker can be male or female, young or old, but the expression on his or her face will make or break the joke. Is the office worker secretly laughing, afraid, bored or dismissive-looking? The expression you choose will put a slightly different spin on whether we are laughing *at* or with the protagonist.

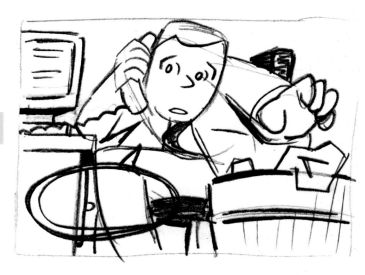

Is the desk ordered or cluttered, and what should be on the desk and immediately surrounding it in order to suggest an office environment?

What is the office worker wearing – does he/she look smart or dishevelled?

And again, from where are we viewing the scene?

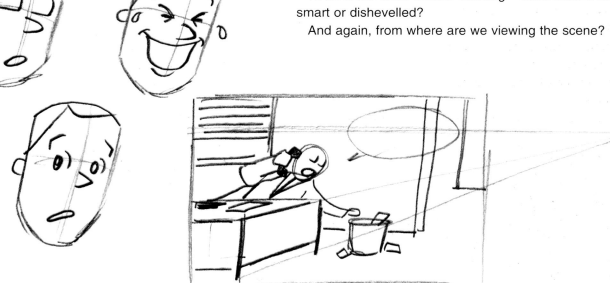

There are many ways to tackle these simple gags. Overleaf you'll see mine, where I'll discuss the reasons behind my choices.

Good luck!

SINGLE PANEL PROJECT ASSESSMENT

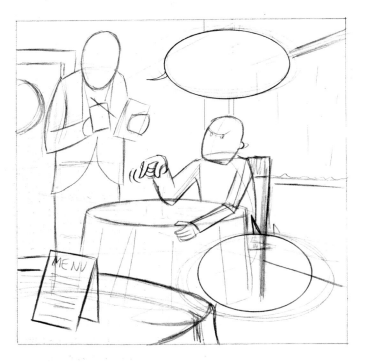

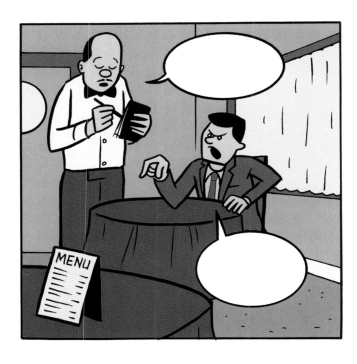

Single panel 1

Here is my pencilled version of the restaurant panel, based on the thumbnail sketch you saw on the previous page. Even at the pencilled stage, there is still time to make alterations.

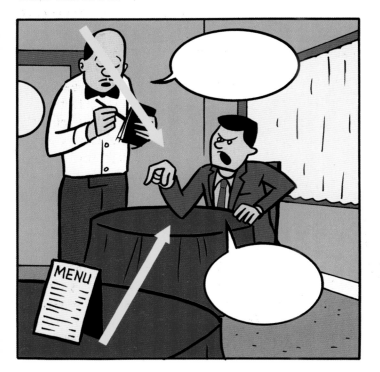

Compare this finished version with the pencilled version and you will see that, at the last minute, I decided to alter the pose of the customer's arm. Before, it was just resting on the edge of the table; now it is bent outwards, giving the customer a more angular outline, which adds to the appearance of his consternation.

The viewpoint of the reader is as though we are sitting nearby, sharing the eye-level of the customer. Warm colours were chosen to give the impression of a cosy bistro-style café.

Here we can see how the composition of the picture leads the reader's eye to the centre of the action: the waiter's head, hand and notebook/menu lead our attention to the customer's jabbing finger; simultaneously, the line-up of the tables and the angle of the menu achieve the same effect.

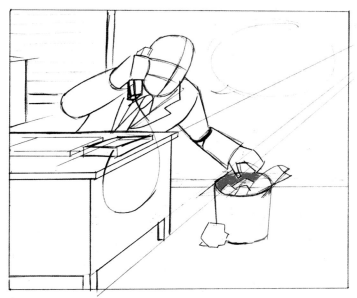

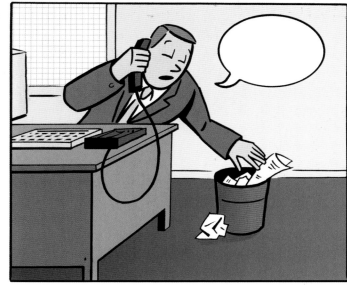

Single panel 2

Here is my pencilled version of our office panel, which needed no alterations before it was finally inked and coloured. A keyboard on the desk should allow the reader to assume that the object intruding into the picture at left is the edge of a computer monitor, and the telephone and some kind of chart on the wall convey our office setting.

The man's suit, the furniture, the wall and floor have been coloured with fairly dull, muted tones, but the waste-paper bin has been coloured red to make it stand out.

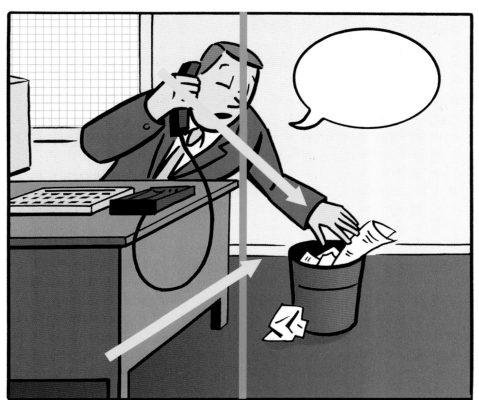

Here, again, note that the edges of the desk and the angles of the guy's hand, head and arm lead the reader's eye toward the "special file". Also, I decided to keep the half of the panel containing the waste-paper bin relatively free of background clutter, so it can be clearly seen.

There are many other ways that either of these scenes could have been drawn. Take a look at your own versions and ask yourself why you chose to draw it in that way. There doesn't always need to be a special reason, but it's always useful to take a second look and consider your choices when composing your pictures, whether for a single panel, or for a sequence in a comic strip.

You can practise further by taking any old joke you might have heard and seeing if you can come up with a single panel cartoon of your own.

Chapter 4:

COMPOSITION AND STORYTELLING

PICTURE COMPOSITION FOR CARTOONS AND COMIC STRIPS

Let's look again at the way we place objects and characters within panels, for single cartoons and for comic strips.

Cut-offs

As you plan your pictures, it's important not to cut off the feet of your characters or lose the top of their heads. It's also vital not to have your characters appearing to stand on the bottom line of the panel border – the reader is not supposed to be aware of the panel borders, in the same way that we ignore the outline of a TV or cinema screen.

Tangents

Beware of "tangents": this is where the lines of the background are directly aligned with the lines of objects or characters in the foreground. This has a flattening effect on your pictures, reducing the illusion of depth. It can be useful to leave a tiny gap between the lines forming the background and those of whatever is in the foreground.

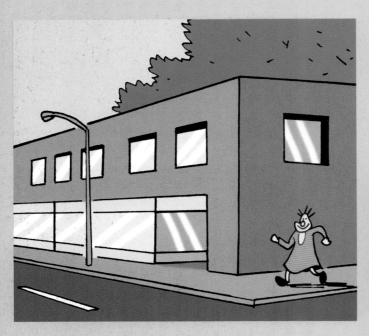

Long-shot

A "long-shot" means when we view a scene from a distance. It allows us to see a lot of the background and is useful when we move to a part of the story that's meant to be in a different location. Once you've established where your characters are, there is often no need to include every detail of the background in each subsequent picture.

Medium-shot

A "medium-shot" is where we view characters from nearby. We might see them from the waist upward and it's a view that is typically used when characters are just talking to each other.

Close-up

A "close-up" is used to clearly show a character's expression, or to bring our attention to some particular detail in the scene.

Typically, a cartoonist will use a long-shot at or near the beginning of a scene to establish its setting, before using a mixture of medium-shots and close-ups to continue the story.

Earlier we examined how the reader's viewpoint may affect their interpretation of a particular scene. Here we've seen that cartoonists have borrowed the language of film-makers to describe different points of view.

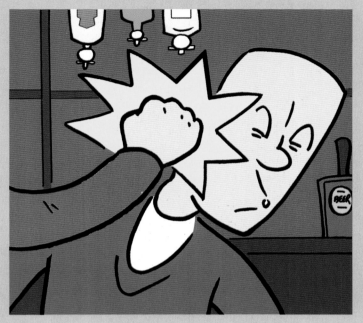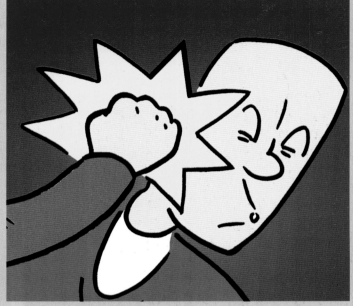

Setting

With a single panel cartoon the cartoonist must decide how important the setting is to the point of the picture, before deciding on how much of the background needs to be seen.

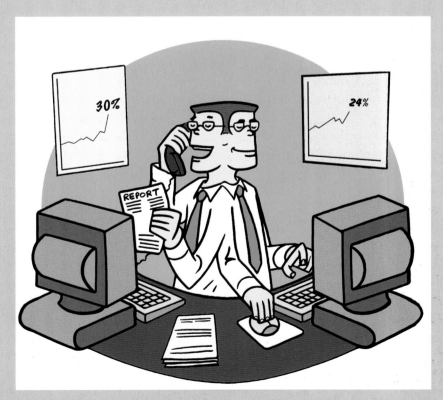

Often, particularly with political cartoons, a few background details will suffice.

When showing some kind of extreme action, the fewer background details the better.

PAGE LAYOUTS

Cartoonists employ subtle techniques when they construct a comic book page. As we've explored, we need to see our characters and the world they inhabit from a variety of views, but that's not all. It can be very useful to consider the way that the reader's eyes move around the page.

It's useful sometimes to compose pictures so that they lead the eye. The arrows in the cartoon below point out the elements that have been used by the cartoonist to lead the eye around.

Our eyes move around a comic book page in this fashion:

Panels 1 to 3: The eye is led from the angle of the guy on the swing, along the slanted horizon of the second panel, into the third where the motorbike tilts down to the left, and then the reader's attention is led back across and down the page by the elongated shadow on the road.

Panels 4 to 6: Our eyes are then led from panel to panel by the angle of the road and buildings in panel 4, along the edge of the road and the chain of the swing in panel 5, and into panel 6, where the second chain of the swing points us down to the bottom left.

Panels 7 to 9: From the couple listening to the narrator's odd tale in panel 7, we're off again, with the composition of panel 8 leading us swiftly to the top right of panel 9, even pointing the way off the page up to the start of the next one. This emphasizes the swinging motion of the protagonist.

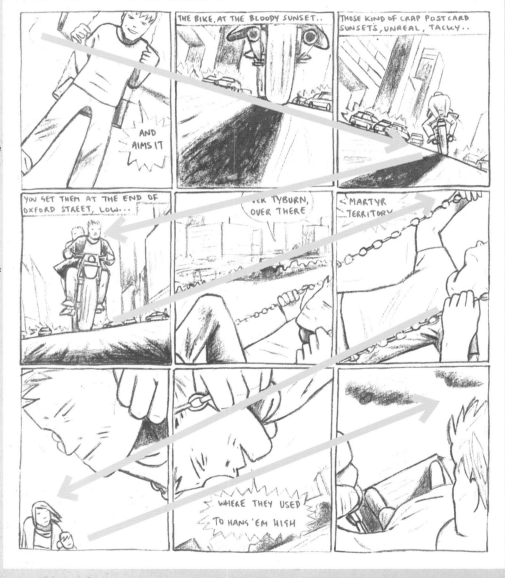

You would probably make your readers giddy and sick if you chose to lay out every page in this fashion, but it's a useful way to involve the reader in the movement of the scene and it's a technique that is often used in super-hero comics when the characters are thumping and zapping each other.

It's not just action scenes that can benefit from this method of panel composition. This comic strip is more conversation than action but becomes a breezy read when the eye is led around.

We've taken the arrows off the comic strip below, but it's clear how the cartoonist is leading the reader. He uses the bar, the sofa, the angle of a shoulder, the angle of a door and the direction that the faces are pointing to take us from start to finish.

REFINING YOUR STYLE

Most cartoonists are associated with a particular style of drawing, a certain way of posing figures, composing pictures, using colour, their choice of drawing materials and quality of line-work, etc. Some employ a variety of styles depending on the task at hand, but will still display common visual nuances in their different types of work.

Here are three distinct styles that I tend to use:

A is an example of a figure drawn in a realistic but stylized manner. Although the proportions of the figure conform to those of a real person, the facial features are simplified somewhat and the directional lines on the hair are quite broadly drawn.

B shows a less realistic approach, with features drawn more simply, and the proportions of the figures reduced to emphasize the characters' heads.

C is drawn in a completely unrealistic style, reflecting the exaggerated pose and expression, giving the picture a dynamic, lively quality.

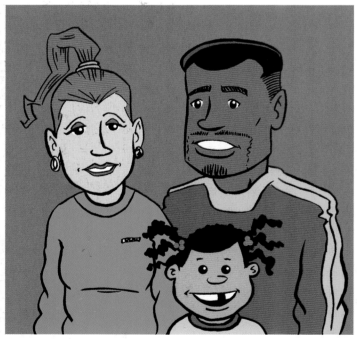

B

C

Examining styles

Every cartoonist is influenced by the work of others and by artists outside the field of cartooning, and these influences will creep into their own work. There's nothing wrong with examining the way that other artists use lines on paper and adopting elements of their style. If you read interviews with your favourite cartoonists in magazines or on the Internet, you'll often find them discussing their own influences and perhaps see examples of how their own style has evolved over many years of work. The cartoonist Paul Jones began his drawing career using a detailed approach to rendering textures. Over time, his work was increasingly influenced by the sleek, simplified style used in Archie comic books, and he managed to incorporate elements of their look without sacrificing his own unique sensibility.

Developing your own style

Here's an engaging and potentially useful exercise that you could try:

Find pictures by two or three cartoonists whose work you enjoy. Beginning with simple stick-figures and shapes, try to copy their pictures in pencil. Then, examine their work carefully.

Does it look as though it might have been inked with a brush or a pen?

What kind of materials might give you the same finish to the work that they achieved?

See if any of their methods might be usefully employed in your own work.

This is not the same as copying someone's style outright, which is generally frowned upon by readers and professionals alike. Successful cartoonists' work reflects their influences, but has its own unique flavour.

However, the style of your work should not be merely the effect of your influences. It should develop through constant drawing and experimentation. Whether you're aiming for a realistic style, or an approach that's quirky and humorous, there are numerous elements to explore.

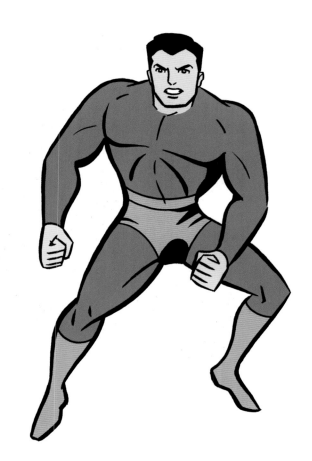

Situations and settings

Super-heroes and their surroundings are sometimes drawn with incredible attention to detail, with the aim of presenting fantastic situations in a naturalistic setting. Some artists use a great deal of hatching and cross-hatching to this end. Equally effective is a pared-down approach, where smooth, flowing outlines imbue the art with a vibrant, kinetic quality. Neither approach is intrinsically "better" than the other; it's a question of individual taste and vision.

Unnatural proportions

Likewise, the level of naturalism in humorous cartooning can be modified by choosing unnatural proportions for figures and reducing the amount of detail in backgrounds and everyday objects and clothing. Of course, there's no reason why humorous cartoons cannot be rendered in an extremely realistic fashion. It's down to you, or to the requirements of your client.

Should you always keep to the same style?

Whichever approach you favour, it's important to keep all the elements of your picture drawn in the same style. A realistically rendered biker riding a simply drawn motorbike will look decidedly odd.

There are two main exceptions to this principle: animated cartoons and Japanese cartoon strips – aka Manga – often show simply drawn characters against detailed, realistic backgrounds. There are historical and cultural reasons for this, so unless it's your careful and considered intention, it can lead to a distracting amalgam of styles and is an approach best avoided by the novice. The simplified background behind this Manga-esque figure has about the right level of detail for it not to clash with the style of the character.

WORKING FROM A SCRIPT

Cartoonists often work from a script that has been written by someone else. This can either be a brief description of a scene for a one- panel cartoon or many pages detailing every panel of a comic strip story. Artists must make their images complement the text perfectly.

As you can see, a script usually resembles the text of a play or movie, indicating whether a scene is indoors or outdoors, and what prominent details need to be seen.

The Graveyard Shift

Page 1

Panel 1 (Long-shot) Exterior Graveyard. Full moon illuminates scene.
 Sam Spook is floating through background, shouting
 to Gordon Ghost, who we can see in foreground.
 Sam looks happy and excited.
Sam: Gordon! Hey, Gordon! Hey!

Panel 2 (Medium-shot) Gordon is facing Sam, who is wearing a
 big, proud smile.
Gordon: Oh, hi Sam... What's new?

Panel 3 (Medium-shot) Sam is proudly holding aloft his new
 aquisition.
Sam: I've got a CELLPHONE!

Promotional Colour Cartoon for JMM Computers Ltd.

"Using the latest software on an outmoded computer is like plugging your expensive new CD player into cheap little speakers."

We need to see a man straining to hear the music coming from two tiny speakers that are attached to a big, expensive-looking CD player.

The first stage in converting prose to comic strip pages is to do preparatory rough drawings, simple small sketches to indicate what will be in each panel.

From these basic sketches, the artist can quickly see whether the story will make sense visually, that the chosen viewpoints are appropriate, and that enough space has been left for captions and word-balloons. At this stage, alterations can be made without a lot of hard work being lost. Occasionally, a client will ask to see the roughs before allowing the artist to continue, in order to make sure that they will get what they are expecting. When everyone is satisfied, these rough drawings are copied onto full-sized art paper, rendered more clearly in pencil, and then inked and coloured.

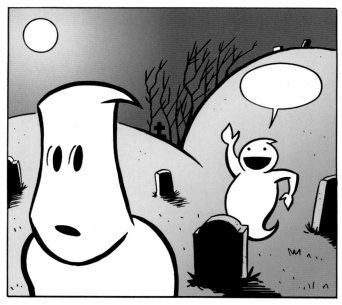

In mainstream, mass-produced comic books that must adhere to a tight schedule, the art chores are usually divided between a penciller, an inker and a colourist, with a letterer adding captions and word balloons at the end. Each of these artists is usually adept at more than one skill, so a penciller could be the inker on someone else's work, and might do all of the work on projects where deadlines are not so important.

The Marvel method

It should be mentioned that in the 1960s Marvel Comics pioneered the method of working without an initial script. Instead, the writer would provide a mere outline of the story, leaving it to the artist to decide exactly how the action would progress throughout the comic book. When the artwork was completed, the writer would then add the captions and dialogue to be given to the letterer.

In the hands of experts, this method worked extremely well and is often used to this day. However, this about-face way of working – art first and story later – can backfire and lead to comics full of pretty pictures and little story when attempted by people new to the business.

FULL-PAGE PROJECT

This project encompasses all of the skills we've practised so far. We're going to attempt a full-page humour strip, working from the script below. Read through it a few times until you begin to form a mental picture of what's going on.

MADAM

Panel 1

A fussy-looking old woman (Madam) is standing in a supermarket aisle next to a pile of cans approximately 2 metres high, stacked in the shape of a pyramid with a base of about ten cans. She is pointing to a can in the middle of the bottom row. A young male Shop Assistant in a long white coat is arranging some small boxes on a shelf nearby.

Madam: *"Young man, I'd like that can of soup down there!"*

Panel 2

The Shop Assistant looks perplexed, and points to the can at the top of the pile.

Shop Assistant: *"Madam, all these cans of soup are the same. Why not take this one?"*

Panel 3

Madam stands with one hand on her hip, and the other gesturing at the entire stack of cans. The Shop Assistant is shrugging and looking skyward with frustration.

Madam: *"Why, look at them! Their labels are slightly torn and some of them are dented! That can is the only one that's perfect!"*

Shop Assistant: *"Oh, very well, Madam. I suppose the customer is always right ..."*

Panel 4

The Shop Assistant is on his knees, attempting to remove the can in question from the stack, which is starting to wobble and a couple of cans at the edges are looking as though they are about to fall.

Shop Assistant: *"Carefully does it ..."*

Panel 5

Exhibiting fitness beyond her years, Madam leaps to the side as the whole stack of cans falls on top of the hapless Shop Assistant.

(Sound effect: "CRASH!")

Shop Assistant: *"Aaargh!"*

Panel 6

The Shop Assistant is sitting amid a pile of cans, holding his head with one hand, and the can of soup in the other. His eyes appear half-closed and his pain should be apparent, either by drawing a large bump on his head or a halo of little stars. Madam is walking away, waving her hand dismissively.

Shop Assistant: *"groan ... Here you are then, Madam ..."*

Madam: *"Oh, I don't want it ... it's got a dent in it now!"*

Picture 1

Our first step should be to design the characters and the setting.

What will our fussy old woman look like?

What kind of clothes should she wear?

We have a description of the Shop Assistant, but what else can we add?

Shall we use different proportions for the characters?

What few details can we include in the setting to clearly show that it's a supermarket?

Spend time doing some rough work to solve these problems.

Picture 2

Next, we'll need to do a rough drawing of the whole page to work out the size of each panel and choose our viewpoints, allow space for the word-balloons, and see if we can make use of the directional lines of our panel composition to carry the reader's eye from one panel to the next. As we'll just be using stick-figures and simple shapes at this stage, we shouldn't worry about changing our minds and redrawing the pictures until we're satisfied.

When we're finally happy with our rough work, we can copy our panel designs onto a clean sheet of paper.

Picture 3

Here's a vital piece of advice: never work right up to the edge of your paper when producing your finished artwork. Always leave a margin of at least 2 centimetres around all four edges of the paper. This will prevent your drawings from being spoiled by finger marks as you handle the page – and more importantly, photocopiers and printers do not print right to the edge of a sheet of paper. They will miss off the edges as they reproduce your work.

If you buy a comic book wherein the artwork reaches right to the edge of the page, be aware that the artwork was drawn with margins and then trimmed to the edges after the book was printed.

As we draw the faces and figures of our characters, we must be mindful to keep their face and body proportions consistent in each picture. We'll need to use perspective guidelines to draw the shelving and other background features. It's a lot of hard work, but the results will be worth it.

Picture 4

With the pencilling completed, it's a good time to add the word-balloons, remembering to write the words first, and draw a balloon around them later. By lettering at this stage, there's still the opportunity to move elements of the picture around if we need to make more room.

Picture 5

Now we can settle down and enjoy inking our work, taking care to only go over the lines that we wish to keep in our final drawing. When the ink is dry, erase the remaining pencil marks, guidelines, etc, and gaze upon your amazing creation.

FULL-PAGE PROJECT ASSESSMENT

Here's my version of the artwork for
our script.

I chose to draw Madam using 3-head proportions, and to keep her at the size of a child, to add a humorous aspect to an otherwise domineering character. Her long, pointed nose gives the character just a hint of veiled aggression. In contrast, the Shop Assistant is drawn using 5-head proportions, close to those of a real person, allowing us to identify with his plight.

Drawing Madam at such a small size made the inclusion of a supermarket trolley, or even a basket, problematic. Either of them would have obscured the character, and possibly a good deal of the background. So, while I would normally recommend one of these as an essential element in establishing a supermarket environment, on this occasion I've had to hope that the shelving layout, the pyramid of cans and the Shop Assistant replenishing the stock are enough to give the reader a clear idea of where the action is taking place.

In Panel 1 I chose to give as broad a view of the environment as possible, with an eye-level between that of both characters so as to emphasize the height of the stack of cans. I've only lightly indicated the items on the shelves to prevent the picture being overloaded with detail. You might notice that only one can at the base of the stack is turned with the label directly facing the reader – the only 'perfect' can …

In Panel 2 we can clearly see that the Shop Assistant is a young, happy, helpful kind of chap, a contrast to the tetchy demeanour of Madam.

In Panel 3 we are brought down to Madam's eye-level before drawing away from the scene slightly in Panel 4, allowing full view of the impending comical disaster in Panel 5. In these four panels, the background details are

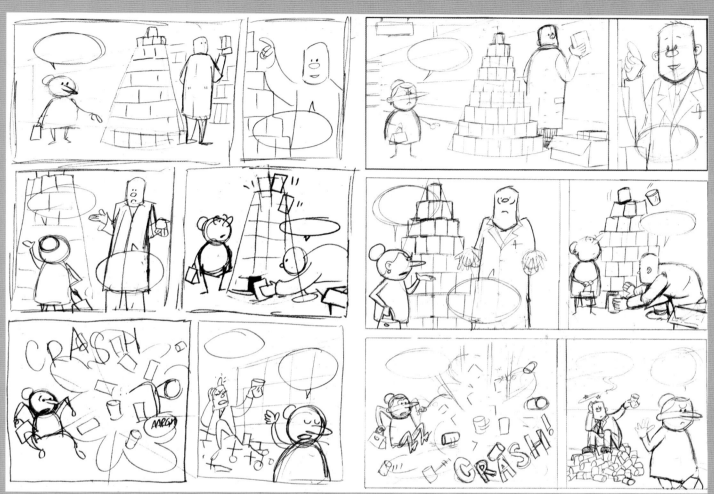

eliminated, allowing us to focus on the protagonists and the subject of the strip.

In the final panel we return to a similar view to that of the first panel, with the background restored. The heap of cans and the dazed Shop Assistant contrast with the placid normality of the strip's beginning. Madam, the Shop Assistant and the reader all share the same eye-level, uniting us all at the very end.

If you compare my finished strip to the pencils and the rough layouts, you'll see that I'm altering minor details right up to the inking stage.

The page was drawn on Bristol Board art paper, using a flexible-tipped pen. White highlights on Madam's clothing and one or two minor corrections were added using a graphics tablet when the work was scanned into the computer. As this book appears in many languages, the word-balloons have been left blank, a common sight on artwork prepared for an international audience. When sound effects are drawn onto the artwork, these are usually not translated as they are mostly onomatopoeic.

I hope your version of this strip compares favourably with my own – for fun, you might even try copying my pencils and inking them yourself, in a strange collaboration across time and space.

Chapter 5:

PRESENTATION AND PUBLICATION

ASSEMBLING A PORTFOLIO

As you build a substantial body of work, it's a good idea to keep your finest pieces clean and safe inside a portfolio case, ready for showing to prospective publishers. The term "portfolio" also refers to the selection of work within, so we'll take each in turn.

Carrying cases

You don't need to buy an incredibly expensive portfolio – it's the quality of the work that really counts – but no-one will be impressed if you pull some folded drawings out of a paper bag.

There are many kinds of slim carrying cases available that are designed specifically for artwork. Some of them contain clips for inserting plastic sleeves in which to put your work, or have sleeves built-in for this purpose. You should always keep your work in plastic sleeves for the obvious reasons of protection from dust and dirt, fingerprints and moisture.

Examples of your work

Your portfolio is your shop window and should contain about a dozen pieces of your best work.

For general purposes, group similar kinds of work together, especially if you've been working in a number of different styles. If you are targeting a particular market, such as children's comics or political cartoons, replace irrelevant material with artwork tailored to that genre.

If you are aiming to impress the editor of a comic book, keep single panel cartoons to a minimum – they will be primarily concerned with how well you can tell a story with images, from panel to panel, and from page to page. It can be very useful to include plenty of drawings of a company's existing characters, but not useful to include characters owned by one of their rivals.

There is absolutely no point in including any work in your portfolio that you do not consider to be your best. However, there may be a couple of pieces that really are "the best of the best". Make sure that one of these is at the front of your portfolio and one at the back. Your prospective client will probably see a great deal of work every week, so it helps to make a great first impression and a lasting impression when he or she finishes looking at your work.

To help ensure that you are kept in mind, it's always useful to have some business cards or a postcard-sized example of your work to leave behind.

SELLING WORK LOCALLY

As a newcomer, the thought of approaching national magazines and international companies might seem daunting. Or perhaps you've already tried and the results have been disappointing.

Major clients always take cartoonists more seriously when they can see examples of work that has been sold. Virtually every successful cartoonist began their career by working locally. Why shouldn't yours begin in the same way?

An easy way to start is by designing your own greetings cards to give to friends. With talent and imagination you should be able to invent something that will stand out from the store-bought cards on someone's mantelpiece. Cards are often left on display for the duration of the holiday season, and for at least a week around birthdays – who knows when a potential client might be visiting?

Your workplace might need someone to provide images for posters and presentations. Your local church, youth club, school or theatre might be delighted to find someone that can help them to publicize an event. Perhaps your local newspaper might be interested in topical cartoons, or a strip that reflects local issues.

At this level, you might end up working for free or for a token amount – it doesn't matter if the ultimate aim is to get some work in print for your portfolio. A professional cartoonist will always give 100% effort to their work, no matter how big or small the client.

As you establish a local reputation, you'll develop the confidence and experience to take on the big boys at a later date.

PUBLICITY AND PROMOTION

You have sketchbooks filled with doodles, piles of drawings on creaking shelves, stacks of CDs containing digital copies of your work, and a portfolio of brilliant illustrations. You're ready to break into the big time. How do you let people know what you can do?

Consider the potential markets for your work

If you enjoy drawing humorous single panel cartoons, then look through national magazines and newspapers to see which ones feature jokes and single illustrations that are in some way similar to your own. Make a note of their contact details and, if possible, the name of their Art or Production Editor.

Contacting clients

Give potential clients a call and tell them you'd like to submit some examples of your work. If they say they would be happy to take a look, ask them by what means they would prefer to see it. Typically, they might ask you to send it to them by e-mail. You'll need to assemble a "mini-portfolio" on your computer – four or five of your best illustrations, and send them along with a brief reminder of your call.

Alternatively, you might e-mail as many potential clients as you can find, without making prior contact. These are known as unsolicited submissions, which can be problematic in that they will probably appear to be junk mail and immediately be deleted.

Unsolicited submissions are best sent through the post. A folded sheet containing five or six examples of your best work will suffice, or if money's no object, you can get postcards made with your work on one side and your contact details on the reverse. Your details could direct the reader to your website.

A website is by no means essential to promote your work, but if you have the means to create one, it could be a very useful showcase. Another way to place your work along the "information superhighway" is to try to sell your work to existing websites. This should be attempted in the same manner that you would approach any other publication.

Occasionally, a potential client may invite you over to examine your portfolio in person, or ask you to leave it at their reception desk so they can look through it when they get the chance. The opportunity to build a face-to-face relationship with a client should not be ignored and plenty of cartoonists have travelled the length of their country, or even further, if an actual meeting seemed loaded with promise.

Comic books

Probably the most competitive arena for cartoonists is the field of professional comic books. Although vast quantities are published around the world, there are even greater

Animation

Some cartoonists aspire to work in the field of animation. There are computer programs that will enable you to create simple animated cartoons for websites and some colleges offer courses that will allow you to learn more sophisticated techniques. Your grounding in the basics of cartooning and storytelling should give you advantages if you are heading in that direction.

Cartoonists are used in a variety of fields

There are many other avenues along which to peddle your wares. Greetings card companies, advertising agencies, charities, computer game companies and government information departments – just think of the many different places that you see cartoons being used to entertain or inform. Someone draws them and it could be you.

A few words of caution! Before submitting your work to anyone, cast a realistic and critical eye over your portfolio:

Does your work measure up?
Is your work as good as the work that they are currently using?

If your honest answer is "no", then it's back to the drawing board for more practice – no-one will hire you on the promise that your work might get better in the coming months. It is better to spend those months refining your work privately, maximizing your chances of eventual success.

Bear in mind that editors receive a great many submissions. If they think they can use your work, they'll let you know, but this might take a long time. Don't hassle them with phone calls or e-mails. If you've not heard anything after six months, then it's probably safe to assume that they weren't interested in the kind of work you showed them at that time. However, if you've been producing new work in the intervening period, perhaps in a different style or to a higher standard, then why not send them some new samples? Polite persistence sometimes reaps dividends.

Never, ever, send your actual portfolio through the mail!

numbers of people competing for the opportunity to work for them.

No-one is offered work on a top-selling title straight away and many people begin by inking or colouring others' work. Most of the major comic book publishers will send "submission guidelines" to would-be artists, outlining exactly the kind of work they are looking for and the manner in which they wish to see it. They will never buy new characters and concepts from unpublished outsiders and, for legal reasons, will not wish to see such examples.

There are many smaller independent comic book publishers who may wish to see brand new ideas. Again, they can send you details of how they prefer to see work and of the kind of material they are seeking.

Comics conventions

Comic book editors often appear at comics' conventions – occasional events held in larger cities – where they usually spend some time looking at portfolios and giving advice. A search on the Internet will lead you to any such conventions occurring near you.

COPYRIGHT, CONTRACTS, MONEY AND TAX

Copyright

The laws of copyright vary slightly around the world, but their central purpose remains universal. You, as the creator, bear the right to benefit from the reproduction of your work and this right is transferable to your next of kin or your legal estate for a designated period upon your demise.

The main exception to this is if you have been working on material wherein the central copyright is owned by another party – if you are illustrating pre-existing characters owned by someone else. In these cases your work is deemed "work for hire": you are a hired hand on somebody else's project.

Contracts

For one-off illustration jobs, contracts are rarely issued, and the rights in the work revert to you after first publication. If your work is intended to be reprinted at a later date, or in foreign editions, or subsequently used in merchandizing or promotion, then a contract should be issued by the client and additional fees agreed.

Many major comic book companies issue contracts wherein you sign away all rights to further payment or ownership of the work. Any characters you design or concepts you create become the property of the company, to utilize as they see fit with no further payment to you. Only the top comic book creators get offered royalty payments (a percentage of the profits) and more equitable contracts. Independent companies tend to offer more rights and royalties in return for a lower payment per page of artwork. Be careful what you sign.

Your actual physical artwork – the ink lines on paper – remains your property and should always be returned if it has to be sent to the client for reproduction – you might wish to sell it or exhibit it at a future time.

Invoicing

You will normally be expected to send an invoice for payment when you complete an assignment. It's a simple task to design a basic invoice containing your name and address with spaces for a reference number and your client's details. You should also add the date of completion, a brief description of the work and the amount of payment agreed. Keep a copy for your files in case of dispute.

Rates of pay

There are no hard and fast rules for determining how much you should get paid – different companies set different rates, so it's worth asking them what they normally pay. If you are asked how much you'll charge for an assignment, then calculate how many hours you'll probably spend doing the work and make a reasonable offer based on this assessment.

Further guidance on rates of pay might be found by contacting a journalists' union or an illustrators' guild. As a beginner, don't expect to be paid the same as a nationally famous cartoonist – but you should expect to get paid the same as anyone else.

Taxes

You should also expect to pay taxes on your earnings as a cartoonist. When you're paid for your first assignment, contact your local income tax office to register as a sole trader. They will send you details of how they will collect taxes owed and of any allowable expenses you can claim. Always keep itemized receipts for any materials, stationery, etc, that you buy in connection with your trading.

Until your income from cartooning becomes your main source of revenue you are unlikely to need an accountant, but you should keep simple accounts of your own; a record of money paid to you and of money that you've needed to spend on your profession will normally be sufficient.

Don't try to cheat the taxman … he's bigger than you!

PREPARING WORK FOR PUBLICATION

You've got work! A big company has asked you to draw some cartoons in return for a substantial amount of money.

Your responsibility is to ensure that, when reduced, your artwork will fit the designated space and still remain clear and crisp. This necessitates certain considerations. If you've ever visited an exhibition of cartoon art, you'll have noticed that the

You want to appear professional, so how do you present your client with the finished artwork?

original artwork is usually considerably larger than the published version.

Cartoonists generally work larger than their work will appear as it's easier and more enjoyable than drawing a tiny picture.

Sizing-up

Imagine your client stipulates that your cartoon must fit into an area 8 centimetres wide and 5 centimetres deep. It's not impossible to draw within those parameters, but it could be an uncomfortable and frustrating process, especially if any amount of detail is required.

Here's how to ensure that a larger drawing will be capable of being reduced to exactly fit its designated final size.

On your drawing paper, mark out the required dimensions in the top left corner and then simply draw a diagonal line through opposite corners and across the page. Use this to construct a larger panel for your picture, assured that it will reduce perfectly to the original measurements.

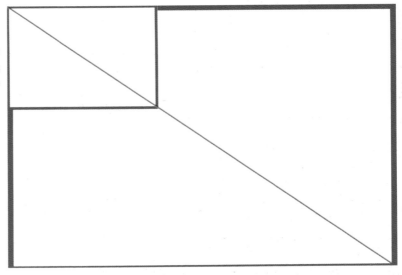

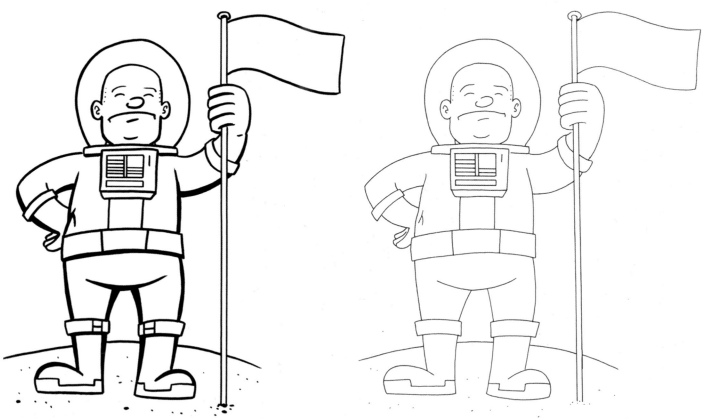

Line thickness

A line drawn at a thickness of 0.5 millimetres or less will virtually disappear when reduced for publication, ruining your hard work. Your lines should be drawn thicker and bolder than you imagine they will look in the published version. Most cartoonists work $1\frac{1}{2}$, $2\frac{1}{2}$, or $3\frac{1}{2}$ times larger than the work will finally appear. To get an idea of how thickly you should be doing the line-work, take a page by your favourite cartoonist to a photocopy shop and get it enlarged by 150%, 200% and 300%. Examine how thickly the lines might have originally been drawn.

Colour: It's important to realize that colour printing rarely matches the brightness of colours seen on the original, whether coloured by hand or on a computer screen. You might need to compensate for this by using slightly richer colours on your artwork. If you are colouring with computer graphics software, it will probably allow you to view the picture in 'CMYK' mode, which mimics the effects of printed colour; if this option is available to you, it will give you a reasonable idea of how the colours you've chosen will look when printed.

Resolution: If you are submitting your work digitally, then ensure that your image's resolution is at least 300dpi (dots per inch) for printing purposes. Web images are usually a mere 72dpi, but it's best to work at a higher resolution and then reduce this afterwards using your computer's imaging software.

Delivery: In these science-fiction times we live in, you might find that you can e-mail your work to the client directly from your computer; or you can copy it onto whatever digital storage medium they prefer, such as a CD, and post it. Never send your valuable original artwork by regular post, there is more chance of it getting lost or damaged. Always make a good-quality photocopy before you send your original, or save a copy on your computer … just in case of accidents. Clients in the television or film business might ask for the original art to be delivered so that it can be filmed on video. In this case, make sure it is securely packaged and sent by a special delivery service or, if possible, take it yourself.

WHERE DO YOU GET YOUR IDEAS FROM?

It would be great if we all had a magic-ideas helmet or if there was a book available called "1001 Story Ideas", but sadly, these things do not yet exist.

Cartoonists often find that if their characters have been developed with a full set of individual quirks, then simply by placing them in a new situation, the contrasts will lead to story ideas. Some cartoonists get ideas while they're walking down the street or sitting on the bus, and to this end they carry a notebook for when inspiration strikes.

Political cartoonists read newspapers, listen to the radio, watch television and peruse the Internet daily, searching for amusing ironies and hypocrisies concerning our leaders.

Beating "creator's block"

Sometimes it's necessary to try and beat "creator's block", to which end we might try this little exercise:

Then consider that all stories are based around conflict – conflict between people, a conflict with the environment, a conflict of ideas, even a character's own internal conflicts. What could happen to cause conflict in your scenario? What problem could occur?

First, decide where your character is, and what they're doing. Are they indoors or outdoors? Relaxing? Working? Just strolling along? Doodle some simple figures and shapes or make written notes.

Next we might see what impact this problem has on the character and on any other characters in your story. How is the situation now different to the way the story began?

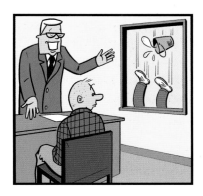

Searching for inspiration

Single panel cartoons benefit from a similar approach. If you're searching for inspiration, why not just doodle some everyday scenes and add a problematic element: a man answering the door to a gorilla; a dentist's arm right down inside a patient's mouth … what amusing captions might these pictures inspire?

Or try it the other way around – take an everyday phrase and think of an unlikely situation where it might be used. Again, these might not be the best cartoons you will ever draw, but it's a process that will begin to get the creative juices flowing. "You're in luck, Mr Smith – we need a new window cleaner …"

It's human nature to try and resolve conflict, to solve problems. What might your character do in order to put things right? Remind the reader what is at stake.

Then let's see the solution in progress. Does it carry an element of risk? Is a successful outcome likely?

The conclusion should illustrate the outcome of our character's endeavours. Is it a happy ending, wherein we share the character's triumph? Is it an unhappy ending to a cautionary tale, as shown in the example here? Perhaps it's even a little of both, leaving the reader with a bitter-sweet resolution to your tale.

This is a simplistic story plan but it might serve to get your train of thought out of the station. Your initial ideas might suddenly spark a preferable idea – it's better to be attempting something rather than just staring at a blank sheet of paper.

FINAL PROJECT – PRODUCING YOUR OWN COMIC BOOK

Finally, let's examine how you can put your skills to the acid-test of public opinion by writing, drawing, printing and selling your own comic book.

Some of the world's most successful cartoonists began their careers by self-publishing their work. For example, Kevin Eastman and Peter Laird, whose Teenage Mutant Ninja Turtles began as a black-and-white, cheaply printed comic book and went on to become a worldwide sensation. The movies *From Hell* and *Road to Perdition* were based on graphic novels illustrated by artists who began their careers in self-publishing … and many, many more cartoonists the world over owe their success to the fact that people could walk into a shop and see their work.

Across the world there is a loose network of people producing their own "small-press" comics, organizing their own distribution services and reviewing each other's work in specialist magazines and on websites. Many of them go on to get paid work – others choose to remain with the creative small-press scene.

In recent years, many websites have been set up, which showcase the work of cartoonists. These have the advantage of being in colour and are immediately accessible to anyone in the world. However, in order to view them, people need to know that these sites exist, entailing a major amount of time and money spent on publicity and links from other sites.

A comic book is portable – it can be enjoyed on the train or the bus, in bed or in the bathroom, or in a comfortable armchair with a mug of coffee. It can be passed around or borrowed without needing a brace of expensive devices in order to read it.

Of course, a combined approach wherein a comic book also serves as a promotional tool for a website is a great idea, and there are many books available that will teach you how to put a website together. However, like newspapers, comic books are a long way from becoming extinct.

So, we're going to look at the nuts and bolts of producing your own comic book, including printing, promotion and distribution.

The Idea

The most vital element is the work itself. Perhaps you already have ideas for characters and stories.

If not, keep in mind that a self-published, small-press comic book need not be constrained by the same commercial considerations that shackle many mainstream publishers to popular genres. A comic book can be based around social issues such as homelessness or the environment. It can cast a spotlight on a type of employment, lifestyle or a minority interest. Auto- and semi-autobiographical comics are perennially popular among small-press devotees.

If, however, you wish to pursue one of the dominant genres of mainstream comics – such as super-heroes or science fiction – remember that your intended customers will most likely prefer to spend money on their tried and tested favourites unless you can somehow make yours unique. Avoid too many similarities to existing characters and on no account use characters that are owned by someone else.

Length

With your characters and ideas in mind, you'll need to make some decisions about the length of your stories. Some comic books feature a number of one- and two-page strips; others contain longer stories or even a complete story from cover to cover. Avoid planning a continuing serial. The start of your career is not the occasion to embark on a 96-chapter epic. The page count of comic books and magazines is always divisible by four,

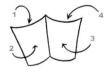
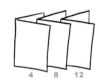

as they are made from folded sheets of paper. Typically, small-press comic books contain at least 12 pages and sometimes are as long as 24 or 32 pages, including covers and any information pages.

Colour

A major consideration is the use of colour. Commercial colour printing is incredibly expensive, which is why 99% of self-published comic books are in black and white. You might consider having a colour cover, but we'll discuss that later.

Let's fast-forward a few months: you've completed maybe 17 pages of artwork for a 20-page comic book. Now is the time to seriously think about an information page and the front and back covers.

Information pages

As your comic book is a showcase for your talents, it's important that readers can deliver feedback. So, you'll need a page containing contact information such as an e-mail address, a website, or even your home address. You might also want to have a cosy chat with your readers, to let them know who you are and how often they might expect to see your work. If you go on to produce more comics, you can use this space to sell back issues and possibly feature readers' letters.

Perhaps most importantly, this is also where you can plainly state that

you hold the copyright on all the material in your comic. Copyright laws vary slightly around the world, but normally the statement:

"All material in this publication is © (your name & the date of publication) and should not be reproduced without permission, except for review purposes …"

is all you'll need for legal purposes. It's actually very rare that anyone has been ripped off when self-publishing, but it never hurts to let everyone know that you'll be keeping a close eye on things.

Cover

The cover of your comic book will be its main selling point, as it is the first thing that the buying public will see.

You have a number of options for your back cover: a single-page strip offering a taste of what's inside; a large single image with some promotional text; it could be left artily blank with just the price of the comic book displayed … whatever you choose, remember that when people pick up a comic book or magazine to browse, they often turn to the back first and flick the pages backward.

Your front cover needs your most considered attention – this is what may persuade a customer to take your comic book off the shelf. You're going to need a snappy title and an intriguing image, or series of images. It's worth going along to a comics shop and scanning the shelves:

Which covers seem to leap out at you? Why?

How can you combine others' ideas with your own to create an eye-catching cover that screams, "Look at me!"?

Whatever design you choose, remember that comic books are

racked horizontally or vertically, so the title needs to be near the top or down the left-hand side.

Yes, as you scan the shelves, you might see mainstream comic books

with their titles at any spot on the cover – that's because people will be entering the shop already looking for that particular title. As a newcomer, you don't have that luxury.

Printing

So, you have a comic book, with covers, and you're ready to go to print. At this point, you'll need to do a little shopping around.

Thanks to new technology, many printers now offer relatively inexpensive rates for producing short

runs of what they normally refer to as "booklets". Some will offer to print directly from your original artwork, or preferably from good-quality photocopies (avoid parting with your originals – accidents do happen).

Others will prefer to work from a CD or other digital storage device, containing scans of your work. It's a good idea to make a "dummy" edition of your comic book from photocopies, show it to printers and ask them how much they would charge you for producing whatever number of comic books you require.

As beginners, we need to be realistic about the amount we might initially sell. There is no point in getting thousands of copies of your first comic book printed: 50–100 will be plenty; you can always get more printed later if you need them. Tales have been told many times of people with 6000 unsold copies of their first comic book in boxes under the bed.

A cheaper and more "hands-on" approach to printing is to use a photocopier. Although time-consuming, it can work out cheaper, especially if you have a sympathetic employer who might let you use the office copier at cost-price per copy – normally a lot less than a commercial photocopy shop. You will have to

figure out how to print on both sides of the paper (some machines will do this automatically but a great many do not); you'll also have to collate and staple each comic book yourself. It will take hours, but the money you save might pay for you to get colour covers printed at a photocopy shop, or using a printer with your home computer. You could print the whole thing at home, but it could cost you a small fortune in ink cartridges.

Sales and distribution

Pricing: Whatever method of printing you choose, the cost should be factored into the price you'll charge for your comic book, along with money spent on distribution. Retailers will normally claim between 30–50% of the price on the cover in return for selling your comic book, so when you decide on its price, make sure that all production costs are included.

How much you decide to add on top, as profit, is completely up to you. Most small-press comic book creators are happy to just break even.

After long months of toil, you'll eventually find yourself staring at a pile of comic books written, drawn and published by you. It's a very satisfying experience. But now you have to get them into shops. Much of what follows relates to our section on publicity and promotion, but here we're going to be specifically talking about self-publishing.

Comic book shops: Many large towns and cities have at least one comics shop, selling a range of mainstream and specialist titles. You'll need to do some research to find your nearest one if you don't already know it; they're normally listed under "bookshops" in the phone book, or else you could search on the Internet.

If your nearest shop is within easy travelling distance, then try a reconnaissance mission. Go along, browse, maybe buy a comic book or two. Ask the assistant if the shop might be interested in selling your self-published comic book. If he or she isn't busy, they might ask to take a look at it, so it's helpful if you've brought a few copies along. If they are busy, ask when it might be a better time to discuss it; comic shops tend to be busiest at the weekend and on "delivery day", when the staff will be trying to sort out their new stock and serve customers at the same time.

If the shop agrees to sell your comic book, they won't take very many copies at first, maybe only ten if you're lucky. If they sell out in a reasonable period of time, then they might ask for more at a later date. Shops will normally offer to sell your

work on a "sale or return" basis, which means that you won't receive any money up front; they'll give you the cover price, minus their percentage, after the comic books have been sold. Any unsold copies will be returned to you. Always get someone to sign a receipt for any copies you leave behind.

It's worth waiting a month before you go back to the shop to see how well your comic book has sold. If it has done well, ask the shop if they'd like more copies; if not, ask them for their feedback – what might you do to improve sales? They're in the business of selling comic books so they might have some useful tips. And bear in mind that different shops have a varying customer-base – a title that does well in a shop frequented by students and professionals might not do so well in a shop that caters mainly to children, or vice-versa.

Other avenues for sales and promotion:
Obviously, your comic book is going to sell more copies if it's stocked by more than one shop. If the first shop you visited refused to stock it, or if you want to distribute more widely, then you'll need to find similar shops. There are hundreds world-wide, and many of them advertise in specialist comic-collecting magazines, which you can buy at comics shops.

You can visit shops further away, or even post them a sample copy of your work with a letter of enquiry (always include a pre-paid return envelope for their reply).

Another way to increase sales is through publicity. There are collectors' magazines and websites that offer to print a critical review of self-published comic books in return for a free copy. You might also find that it's relatively inexpensive to take out a paid advertisement in one of these publications.

The same magazines will also contain details of comics' marts and conventions, where fans gather to buy comic books from retailers who travel the country. These events are a great opportunity to try and get your comic book sold on as many tables as possible, and also provide an occasion to meet other small-press creators.

There are distribution networks that specialize in self-published comic books – they will help you to promote your work. You might meet people that self-publish anthologies of others' work. If nothing else, you'll certainly have the chance to buy other small-press comic books and be able to see how yours measures up against the rest.

Consider other avenues for selling your creation. If your comic book has some kind of central theme, such as "sport" or a particular lifestyle, try offering it to non-comics shops that cater to the same interests. Bookshops belonging to smaller chains or run independently often sell small-press publications of every description. Even your local newsagents might be interested in helping a regular customer.

You can see that distributing and selling your work can be a time-consuming process. If there are

times when you consider quitting, remember that many people have reached this point and given up.

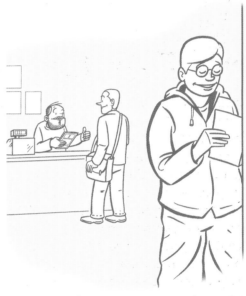

This is why every self-publisher is not a household name; only those that ploughed on through the difficult times have eventually achieved recognition and big rewards.

Now it's your turn ...

110

GALLERY

GALLERY

Welcome to the final section of our book: The Gallery.

Here you can see work by cartoonists that have been published in various countries across the world. Many of those featured do not appear regularly in the comic books that you might purchase from your local newsagents; instead, they've achieved fame producing cartoons for children's books, graphic novels, websites, newspapers and magazines.

It's important to realise that cartooning is not a skill solely used for the amusement of children.

Words and pictures can be combined on the printed page to communicate any idea, and any kind of story. The range of different styles on display over the next few pages should illustrate that the skills we've examined in this volume can be applied in many different ways, and for many purposes. You will also see examples of some areas we've covered, such as perspective, picture composition and the careful use of colour. Maybe you'll be inspired to seek out more work by these gifted individuals. A quick search on the Internet should yield fascinating results.

DAN CLOWES

Contrasting styles: Dan Clowes contrasts detailed line-work with a looser approach to depict a struggling cartoonist alone with his hopes and dreams. Thoughts of success and posterity are overshadowed by a central fear that his work will be overlooked in favour of some other cartoonist's output in this bitter-sweet portrait.

NICK ABADZIS

Nick's career has taken some wild turns. He's written and drawn the adventures of young everyman Hugo Tate for the fondly remembered Deadline comic magazine. He was an editor at Marvel Comics' UK division. When a bizarre illness prevented him from drawing for a year, he wrote a mini-series, *Millennium Fever*, for DC Comics. He's recently been the art director for a series of educational magazines in the UK and established his own publishing company, writing and drawing the Pleebus Planet series of comic books for the children's market.

LEANNE FRANSON
Leanne lives in Canada, where she writes and draws her own comic, *Liliane*, between commercial illustration jobs for the children's market. In the 1990s she lived in the UK for a while and taught at the London Cartoon Centre. She's indebted to the famous US cartoonist Jules Feiffer for inspiring her style of loose, expressive line-work.

HUNT EMERSON

The prolific Hunt Emerson is famous for his comic-strip adaptations of great literary works, including *Lady Chatterley's Lover* and *The Rime of the Ancient Mariner*. Here we can see his jazz-loving creation Max Zillion moving through a surreal, twisted landscape reminiscent of George Herriman's 1920s strip *Krazy Kat*, with a hint of Van Gogh for good measure. The blues, greens and browns of the dark alley contrast with the hot pink, yellow and orange of the club's entrance, promising exotic delights within.

PAUL GRIST

Paul's work appeared during the first bloom of the UK's small-press comics scene in the 1980s. Since then, he's formed his own publishing company, writing and drawing the industry-award-winning Kane and Jack Staff, which is currently licensed to a huge US publisher.

An Exact Sense of Place:

There's not a brick or roofing tile out of place thanks to Paul Grist's masterful use of perspective, enhancing the sense of danger as this figure leaps across the rooftops.

ILYA

Less is More: Scraps of paper blowing in the wind lead the eye down a street of derelict houses. Ilya uses fewer and fewer lines to draw each successive building, which combines with simple perspective to create a sense of distance.

PAUL JONES

As well as being a superb cartoonist, Paul also taught cartooning classes for children around the UK. Also known as "Jone-Zee", his work appeared in numerous newspapers and magazines, notably the *Daily Telegraph* and the BBC's *Girl Talk*, and he self-published his own comic book, *Ain't Life A Blast*. Sadly, Paul died in a road accident in 2001.

A Limited Palette: Paul Jones uses differing shades of the same blue on almost every facet of this picture to show that the characters are lit by the glow from the television. Even the fairy lights' colours are muted, so as not to detract from the overall ambience.

ROGER LANGRIDGE

Roger grew up in New Zealand but has spent the last couple of decades in the UK, where his work has appeared in a brace of publications, as well as drawing strips for the US market – his *Batman: Legends of the Dark Knight* remains one of the best I've seen!

Roger's Internet cartoon strip *Fred the Clown* also appears as a good old-fashioned comic book.

DAVID LLOYD

Chiaruscuro: Only the areas in shadow are used by David Lloyd to define the form of this cloaked, running figure. Its lighter areas are left to bleed into the light of the background, giving the character a stark, menacing quality.

CAROL SWAIN

Carol is an accomplished fine artist who chooses to work in comics from time to time. She brings a painterly sensibility to her work, which often has a languid, dream-like quality. Though her output is sporadic, she's widely published in the US.

Unconventional Materials:

Working with pastel crayons and soft pencils, Carol Swain combines colour and black-and-white work within the same picture to create a hazy, dream-like setting for her characters. The angles of the figure in the foreground, the pier and the balloon's string lead the eye to the figures in the background.

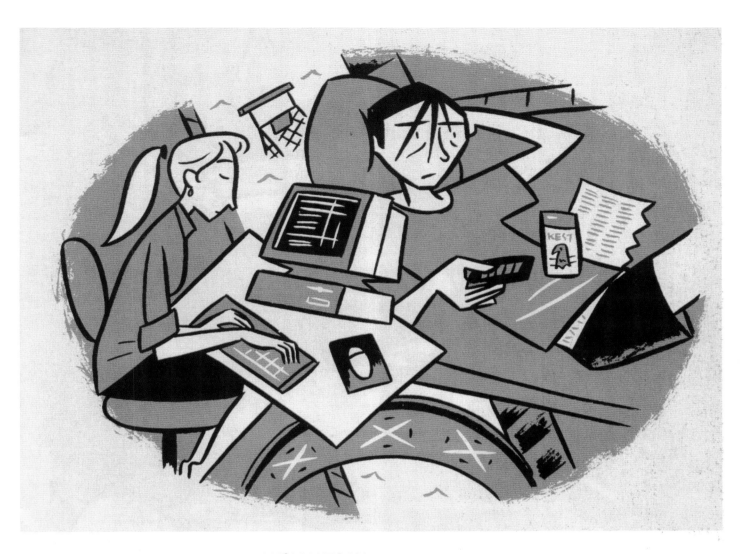

ANDI WATSON

Andi began his career doing Manga-inspired work before falling under the spell of European cartoonists and producing thoughtful, moving tales of ordinary life, such as *Slow News Day* and *Dumped*, for the US publishers Slave Labor and Oni Press.

INDEX

A

Abadzis, Nick 114
accounts 100
action figures and dolls 37, 53
adults, proportions 38
age, character's 31
animals 38, 40–1, 47, 53
animation 87, 99
anthropomorphous animals 38, 40–1, 47, 53
arms 38, 39, 46, 48–9, 52
artwork, preparing for publication 91, 101–3
atmosphere *see* emotional qualities

B

back covers 107
back (rear) views 30–1, 43
backgrounds
 colours 18
 hatching (line-shading) 16–17, 86
 placement 79–81
 scene dressing 68-9, 72–5, 92–3
balloons (word balloons) 13, 20–1, 72–5, 88, 91, 93
ballpoint pens 12, 13
bevelled surfaces, drawing guides 13
bird's-eye views 56, 71
Bitmap format 23
books, self-publishing 106-9
bookshops 108–9
brickwork 57, 117
briefs and outlines 88–9, 90–3
Bristol Board 11
brow ridges and eyebrows 32, 41
brush-pens 13
brushes 13, 16
buildings
 interiors and furniture

58, 60–1, 64, 66–7, 68–9, 72–5
 perspective 56–9, 62
burglars 44
butchers 44

C

cafés and restaurants 68, 72, 74
caption boxes 20
cars 58, 63, 65
cartridge paper 11
characters
 see specific types (eg animals) and attributes (eg expressions)
children, proportions 38
circles 13, 59
clichés 44, 68–9
clients, potential 96–9
close-ups 80
clothes and costumes 18, 43, 44, 50
Clowes, Dan 113
CMYK mode 103
cold colours 18, 19
colour printing 107
colouring 18–19, 89, 103, 116, 119
comic book shops 108–9
comic books
 self-publishing 106–9
 working for 88–9, 98–9
comic strip stories
 ideas and inspiration 104–5, 106
 page layouts 82–3
 projects 90–3
 working from scripts 88–9, 90–3
complementary colours 19
computers 22–3, 98, 99, 103
conflict, as story inspiration 104–5
contact information, in self-published books 107
contracts 100

conventions and marts 99, 109
copyright 100, 107
correction fluid 13
costs, self-publishing 107–8
costumes and clothes 18, 43, 44, 50
covers 107
creases
 clothes 44
 facial 31
creator's block 104–5
cross-hatching 16, 17, 86
crotch 38, 39
cut-offs 78

D

delivering work 103
depth, texture, form and shadow 15–17, 48–9, 79, 118, 121
dialogue *see* scripts; speech
dip-pens 12, 16
distribution and sales 108–9
dolls and action figures 37, 53
drawing guides 13
drawing spaces and surfaces 10
dummy editions 108

E

e-mail 98, 99, 103
earnings 100
ears 26–7, 29, 30–1, 33, 37
Eastman, Kevin 106
elbows 39, 44
ellipses (ovals) 13, 59
Emerson, Hunt 116
emotional qualities
 colours 18, 19, 74–5
 facial expressions 32–3, 41, 72–3, 92

moving figures 46–7

 viewpoints 70–1, 72–5, 80

environment, establishing
68–9, 72–5, 80, 92

equipment and tools 10–13, 96

erasers and erasing 11, 14

expressions, facial 32–3, 41, 72–3

exteriors *see* outdoor scenes

eye-levels and perspective 56, 60, 71

eyebrows and brow ridges 32, 41

eyes (characters) 26–7, 29, 30–1, 33

eyes (readers), leading around page
21, 82–3

F

faces 26–33, 72–3, 92

 animals 40–1

 projects 29, 34–7

families 34–7, 50-3

feathering 16, 17

features *see* specific features (eg ears)

feet 45

Feiffer, Jules 115

figures 38–49, 67

 poseable figures and dolls 37, 53

 projects 50–3

file formats and resolution 23, 103

financial matters 100, 108–9

flicking 16, 17

foreshortening 45, 48–9, 51, 53

form, shadow, depth and texture
15–17, 48–9, 79, 118, 121

formats and resolution 23, 103

fountain pens 12

Franson, Leanne 115

French curves 13

front covers 107

furniture and interiors
58, 60, 61, 64, 66, 67

G

graphics programs 22–3, 103

graphics tablets 23

greetings cards 97, 99

Grist, Paul 117

guidelines

 faces 26–7, 30–1, 40

 figures 38

 lettering 20

 perspective 57–67

H

hair 29, 33

hand-lettering 20–1, 89, 91

hands 45

hardness, pencils 11

hatching (line-shading) 16–17, 86

heads

 shape 26–7, 34–7

 units of measurement 38

horizons 56

hospitals 69

hot colours 18, 19, 116

houses and buildings

 interiors and furniture
58, 60–1, 64, 66–7, 68–9, 72–5

 perspective 56–9, 62

I

ideas and inspiration 104–5, 106

Ilya 118

income tax 100

India ink 12, 13

influences, stylistic 85

information pages, in self-published books 107

ink erasers 11

inking 89, 91

equipment and inks 12–13, 19

line thicknesses and quality
12, 14–15, 16, 102

interiors and furniture
58, 60–1, 64, 66–7, 68–9, 72–5

invoicing 100

J

Japanese comics (Manga) 16, 87

joints (knees and elbows) 39, 44, 52

Jones, Paul 85, 119

JPEG format 23

judges 44

K

knees 39, 44, 52

L

Laird, Peter 106

Langridge, Roger 120

legs 38, 39, 46, 49, 52

lettering 20–1, 89, 91

limbs (arms and legs)
38–9, 46, 48–9, 52

line-shading (hatching) 16–17, 86

line thicknesses and quality
12, 14–15, 16, 102

Lloyd, David 121

local sales 97

location, establishing
68–9, 72–5, 80, 92

long-shots 80

M

magazines and newspapers
97, 98, 109

Manga (Japanese comics) 16, 87

margins 91

marker pens 12
marketing your work 96–9, 108–9
marts and conventions 99, 109
Marvel Comics method 89
mass-production 89
mechanical (propelling) pencils 11
mechanical tones 16, 17
medium-shots 80
money matters 100, 108–9
mood *see* emotional qualities
mouths 26–7, 29, 30–1, 32–3
moving figures
 39, 42, 46-7, 49, 51, 52
muscles 42–3

N

newspapers and magazines
 97, 98, 109
noses 26–7, 29, 30–1
nylon brushes 13
nylon-tipped markers 12

O

offices 68, 73, 75
one-panel cartoons
 see single panel cartoons
one-point perspective
 57, 60–1, 65, 66
outdoor scenes 62–3, 65, 68, 69
 buildings perspective 56–9, 62
 vehicles 58, 63, 65, 66
outlines and briefs 88–9, 90–3
ovals (ellipses) 13, 59

P

page count, comic books 106–7
page layouts 82–3

panel borders 78
paper 11, 23
pay 100
pencil sharpeners 11
pencilling 14, 89
 see also preparatory drawings
pencils 11
pens 12, 13, 16
peripherals, computer 22–3
perspective 56–63, 67, 71, 117, 122
 projects 64–7
photo-quality paper 23
photocopies 19, 102, 103, 108
photocopying inks 19
photocopying paper 11
photographic sources 35, 63, 68
plastic erasers 11
political cartoons 81, 96, 104
portfolios 96, 98, 99
preparatory drawings and roughs
 14, 38, 72–5, 88, 91
 stick-figures
 39, 42, 46–7, 50, 52, 91
pricing 108–9
printers and printing 23, 107–8
profiles (side views)
 30–1, 36–7, 39, 43
projects
 comic book production 106–9
 comic strip stories 90–3
 faces 29, 34–7
 figures 50–3
 perspective 64–7
 single panel cartoons 72–5
propelling (mechanical) pencils 11
proportions
 faces 26–7, 30–1
 figures
 38–9, 41, 50, 52, 84, 86, 92
 places and objects 66

publication
 preparing work for 91, 101–3
 self-publishing 106–9
publicity 109

R

readers, leading around page
 21, 82–3
realistic and unrealistic styles
 28, 84–7
rear (back) views 30–1, 43
reducing and sizing up 12, 16, 101–2
resolution and file formats 23, 103
restaurants and cafés 68, 72, 74
rights (copyright) 100, 107
roughs and preparatory drawings
 14, 38, 72–5, 88, 91
 stick-figures
 39, 42, 46–7, 50, 52, 91
royalty payments 100
rubber erasers 11
rulers 13

S

sable-hair brushes 13
sales and distribution 108–9
scanners 22
scene dressing and setting
 68–9, 72–5, 80, 92
scripts, working from 88-93
seated figures 39, 46–7, 49, 53
self-publishing 106–9
selling your work 96–9, 108–9
set-squares 13
shadow, depth, texture and form
 15–17, 48–9, 79, 118, 121
sharpeners, pencil 11
shops and supermarkets 90–3
shouting 20

side views (profiles)
30–1, 36–7, 39, 43
single panel cartoons
81, 88–9, 96, 98, 105
projects 72–5
sizing up and reducing 12, 16, 101–2
sketchbooks 68
small press comics 106–9
snouts 40
software 22–3, 99, 103
sound effects 21, 93
sources, photographic 35, 63, 68
spectacles 37
speech 37, 80
word balloons
13, 20–1, 88, 91, 93
spine 46–7
stereotypes 44, 68–9
stick-figures 39, 42, 46–7, 50, 52, 91
stippling 16
storage devices, computer
23, 103, 108
stories *see* comic strip stories
streets *see* outdoor scenes
strip stories *see* comic strip stories
styles 28, 84–7
Gallery 112–23
submitting your work 96-9
super-heroes 32, 38, 42–3, 44, 59,
83, 86, 106
supermarkets and shops 90–3
Swain, Carol 122

T

tangents 79
taxes 100
teachers 44
technical drawing pens 12
templates 13
texture, form, shadow and depth

15–17, 48–9, 79, 118, 121
thought bubbles 20
three-point perspective 59, 71
three-quarter views 30–1
TIFF format 23
tights, super-heroes' 43
titles, self-published books 107
tools and equipment 10–13, 96
two-point perspective
58, 62–3, 64, 66–7

U

underpants, super-heroes' 43
unrealistic and realistic styles
28, 84–7
unsolicited submissions 98–9

V

vanishing points
figures 67
one-point perspective
57, 60–1, 65, 66
three-point perspective 59, 71
two-point perspective
58, 62–3, 64, 66–7
vehicles 58, 63, 65, 66
viewpoints
emotional effects
70–1, 72–5, 80, 92
faces 30–1, 34–7
perspective 56, 60, 71

W

waterproof inks 19
Watson, Andi 123
websites 98, 103, 106, 107, 109
whispering 20
windows 61, 62, 65

word balloons
13, 20–1, 72–5, 88, 91, 93
Word format 23
worm's-eye views 56, 71

ACKNOWLEDGEMENTS

The author would like to thank: Nick Abadzis; Dan Clowes; Hunt Emerson; Leanne Franson; Paul Grist; Ilya; Sian Chilcott, Peter and Wendy Jones, Lynn Jones for Paul Jones; Roger Langridge; David Lloyd/DC Comics; Carol Swain; Andi Watson for kindly agreeing to allow us to use their work in this book.

Special thanks go to the following for all their help and support: Doreen, Barry and Jon Marchant; Emma Connolly; Eve Stickler; Bruce Paley; Mike Slocombe; Paul Gravett; Dennis Hunter; Alvan Wright; Winston Weston; Alan Tranter; Batman; my editors, Emma Baxter and Jane Ellis.

This book is lovingly dedicated to the memory of Paul "Jone-Zee" Jones (1963–2001) – cartoonist, colleague and friend.